The Apple Photos Book for Photographers

Apple Photos Book
for Photographers

Building Your Digital Darkroom
with Photos and Its Powerful
Editing Extensions

rockynook

The Apple Photos Book for Photographers
Building Your Digital Darkroom with Photos and Its Powerful Editing Extensions

Derrick Story
www.thedigitalstory.com
www.theNimblePhotographer.com
www.theAnalogstory.com

Editor: Joan Dixon
Copyeditor: Stephanie Pascal
Layout and type: Hespenheide Design
Cover design: Charlene Charles-Will
Project manager: Lisa Brazieal
Marketing manager: Jessica Tiernan

ISBN: 978-1-68198-118-5
1st Edition (1st printing, October 2016)
© 2016 by Derrick Story
All images © Derrick Story unless otherwise noted
Cover images: Adobe stock images

Rocky Nook Inc.
1010 B Street, Suite 350
San Rafael, CA 94901
USA

www.rockynook.com

Distributed in the U.S. by Ingram Publisher Services
Distributed in the UK and Europe by Publishers Group UK

Library of Congress Control Number: 2016930694

Derrick Story is a professional photographer, writer, and online publisher based in Santa Rosa, California. He covers digital imaging, including Photos for macOS, at www.theDigitalStory.com. For those who have a passion (or curiosity) for film photography, be sure to visit Derrick at www.theAnalogstory.com. He also maintains an online journal about photography and life at www.theNimblePhotographer.com.

Derrick has published more than 20 video training titles on lynda.com. His trainings include Photos for macOS, Capture One Pro, Flickr, Dropbox, and live action titles on shooting high school senior portraits and travel to Cuba.

You can follow Derrick on Twitter (Derrick_Story), Instagram (DerrickStory), and Facebook (www.facebook.com/thedigitalstory/).

As a kid, I had a darkroom in a cramped space under the stairs. I probably lost half of my dad's tools learning how to disassemble bikes. And for birthdays and at Christmas, I received books and toys from my mother, who fostered my budding creativity.

As I grew older and my interests became more complex, my parents continued to stand behind me, even when they had no idea what I was really trying to achieve.

A writer's journey can be a twisted road, and I certainly explored every option except for the one most parents would want for their child. Yet, my parents stood fast as my supporters. I never doubted that I was loved.

It's long overdue that I dedicate a book to my mother, Lynn Story, and to my father, Ron. Folks, I might have made it without you, but I'm so happy I never had to try.

—Derrick

Table of Contents

First Things First

Photos for macOS replaces not one but two venerable Apple applications: iPhoto and Aperture. Those are tough acts to follow.

If Photos is your first imaging app ever, then this makes little difference to you. The paint is fresh, the carpets are clean, and there's a light breeze blowing in through the window. Welcome!

For most of us, this isn't our first attempt at finding a place to organize our pictures, improve their appearance, and share them with others. Some of us are refugees from Apple's abandonment of Aperture and iPhoto, and others just haven't found a home that feels right yet.

Regardless of your history or lack thereof, I'm glad you're here. Why? Because on first blush, this looks like a modest place. But Photos has an incredible array of features to make your photography easier and more creative. I might not show you every nook and cranny; we don't really need to explore the attic right now. The things I want to share are what I consider important. Then I will give you some breathing room and let you decide for yourself how to move forward.

Figure 1-1: Welcome home!

After all, I'm hoping this will be your new photography home.

The Guy Before You

Thunderous applause is the last thing you want to hear for the person who just spoke before you. This could happen in the classroom, at work, or even at a social gathering. Oh sure, on the outside you're happy for them. But inside, nobody likes to follow someone who has just knocked it out of the park.

This plays out in many ways. How about the guy that replaced Michael Jordan after he retired from the Chicago Bulls? I bet that was fun. Movies try to

do this with sequels. The first release was a smash, so let's do it again. Sometimes it works out.

And there's the world of software. Here we are with Photos for macOS—Apple's second act. Those who had stuck with Aperture all of those years had come to love it. I didn't sense quite the same affection for iPhoto, but there wasn't much disdain either. iPhoto was like the friendly next door neighbor who suddenly disappeared one day. You felt a little sad at first. Then you went back to watering the lawn.

Apple is no stranger to turning over the cart. They've done it with hardware (you don't need an optical drive) and with software (you'll be working with Final Cut X now). And most of the time, they've pulled it off. I think Photos for macOS is going to fall into this category.

To be honest, Photos for macOS hasn't really received a fair shake. Aperture refugees lament missing features. And they may never learn to love again. A lot of iPhoto folks weren't sure what they were doing in the first place and are now more confused than ever. (I don't mean you, of course.) Then there are people coming to the Mac by way of the iPhone. They have their hands full learning a new operating system and figuring out how iCloud works.

So I wrote this book for all of these people. For you. Because I think you

and Photos for macOS should get a fair shake. If the two of you spend some quality time together, I think you'll find a lot in common. I'm not saying that you're going to get married and have kids or anything, but the friendship could be rewarding.

Someone once told me that a good relationship is one where both parties feel like they got the best deal. Photos for macOS is free. (Well, except that you have to buy a Mac. That's an old Steve Jobs joke, by the way.) It can protect your valuable memories, even if your phone, tablet, or Mac is lost or destroyed. It automatically backs up your images to iCloud—that is, if you let it.

Photos can make your pictures look better. Its editing tools are outstanding. And the third-party editing extensions that are rolling in to the Mac App Store are taking creativity to another level.

And just as important, Photos is friendly. It really is. All of this seems like a good deal to me. What does Apple get out of it? Well, if you learn to love Photos, you'll probably keep buying Macs, iPhones, and iPads. That's not bad for them either.

Think about that boy who has to walk on stage after the kid just before him gets a standing ovation. He probably has something wonderful to offer. But you have to give him a chance. Now's the time to do that.

The Photos Library

There are so many things I want to show you about this app. But we have to take care of a little business first, and the priority is the Photos library. This innocent-looking container nestled in your Pictures folder is *your* part of this application. This is where your images are stored. Look for *Photos Library*. If you double-click on it, Photos launches and is ready for action.

If you've never launched Photos for macOS, then start up will be different. If that's the case, then click on its icon located in the center of the Dock. Doing so will cause one of three things to happen: If you have an iPhoto library in your Pictures folder, Photos will automatically migrate and open that library. If you have multiple iPhoto libraries, Photos will ask you which one to migrate. And if you have none, Photos will just open

Figure 1-2: Photos libraries in my Pictures folder. The top one is the System Photo Library.

and show you a screen describing different ways to add content.

My favorite approach is to start fresh and learn this app with just a few pictures. But it may already be too late for that. Or maybe not. Read on. I'm going to say all of this again, but with a bit more detail.

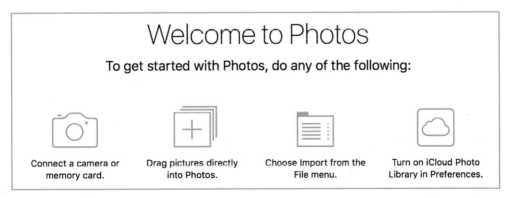

Figure 1-3: You got nothing yet? Apple has some suggestions.

Starting Fresh or Moving Over

Chances are good this isn't your first rodeo on a Mac. As such, you may have an iPhoto or Aperture library already in your Pictures folder. When you launch Photos, it will find that library and open it. If it's your first Photos library it will be designated as the System Library. The System Library is the one that is connected to your entire Apple ecosystem. If Photos has already grabbed an iPhoto library and made it your System Photo Library, don't worry. Things will be fine.

If that hasn't happened yet, I have a tip for you. If you don't want Photos to automatically grab an existing iPhoto library, hold down the Option key when you launch the app. That will take you instead to the Choose Library dialog. Click on the Create New button, and

Figure 1-4: Not quite ready to bring in your legacy content? Hold down the Option key at launch to get the Create New option.

use the standard name: Photos Library (provided that name hasn't already been used). Now you can start fresh, even if you have iPhoto or Aperture content in your Pictures folder. You can deal with those libraries later.

> **TIP**
>
> If you don't want Photos to automatically grab an existing iPhoto library, hold down the Option key when you launch the app.

The System Photo Library

It's easy to end up with more than one Photos library, especially if you're migrating from Aperture or iPhoto. But only one of these can be the System Photo Library. It's the one that has iCloud connectivity. If you've been playing with Photos prior to migrating from Aperture or iPhoto, you already have a System Library, and the others you added are secondary.

If you don't know which of your libraries is the System Photo Library, hold down the Option key and launch Photos. The Choose Library dialog will appear, and in that list your System Photo Library will be labeled as such.

Secondary Libraries

Anything that's not the System Photo Library is a secondary library. Secondary libraries behave the same, except they don't have iCloud connectivity. I think

these are perfect for migrating Aperture or iPhoto libraries. You still have access to those pictures in Photos, but you're not dumping a bunch of content into your iCloud account and onto your mobile devices.

Switching Among Libraries

As I've mentioned before, you can switch among libraries by quitting Photos, then holding down the Option key and relaunching it. That will bring up the Choose Library dialog box where you can click on the one you want to open.

What Is a Referenced Library?

A *referenced library* is where the master files are stored outside the Photos library container. The application knows where these masters are, and it *references* them. If you've run a referenced library in Aperture or iPhoto, it's similar to that here. But I don't recommend using the Referenced Library approach unless you're an advanced photographer with some experience in this area. At least not yet. Let's first get out of chapter 1 unscathed.

Migrating from iPhoto or Aperture

So, what happens if you do migrate an Aperture or iPhoto library to Photos? Do you lose the ability to open it in its native app? Actually, you don't. Here's an overview of migrating from Aperture to Photos. I've done this many times.

Now before you consider this, my advice is to work with a small Aperture library that you have backed up on an external drive. Do not attempt to migrate your huge master Aperture library without testing first. *Please heed this advice.*

Once you've found or created a small test library, follow these steps:

1. Click on your Aperture library, and drag it to the Photos application icon on the dock.
2. Wait for Photos to process the new library and open it.
3. Test the migrated library by clicking around in Photos to see how things look.
4. Return to your Pictures folder and take a look at what are now two libraries. One will read *migratedaplibrary* (your Aperture library name has changed), and you'll have a *photoslibrary* version.

Figure 1-5: Photos has to think for a bit when converting an Aperture or iPhoto library

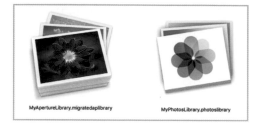

MyApertureLibrary.migratedaplibrary MyPhotosLibrary.photoslibrary

Figure 1-6: The original Aperture library and the new Photos library side by side in the Pictures folder

Both libraries are independent. You can continue to work with the migratedaplibrary in Aperture, but the changes will not be reflected in the Photos library and vice versa. If you wish, you can remove the migratedaplibrary from your Mac, and the Photos library will still work. My advice, however, is to back up the Aperture library before trashing it. In general, be cautious and do redundant backups before migrating libraries.

What Comes Over and What Doesn't
Since Photos doesn't support star ratings or color labels, those automatically become keywords in their new home. Many of the image edits will survive the migration, but you probably won't see the actual settings in the Adjustments panel . . . most of the time. I have seen the Sharpening settings come through, though. But, if you hold down the M key (for master), you will be able to see the unedited version, even though what started as an Aperture picture is now in Photos.

The structure inside Photos goes something like this: Everything from the migration goes in a folder called *iPhoto Events*, placed in the My Albums area of Albums. If you open that folder, everything should be in there. But again, this is where testing becomes so important, so you can see how things work with your particular content.

I'm covering Aperture and iPhoto migration because this may be top of mind for you. My preference is, however, that you take this as an FYI for the moment. Now you know it can be done and you have some idea of what to expect. Great! What I'd like to do is focus on how Photos works first and then learn to master it. Then, if you want to migrate, you can start building a plan.

BACK UP YOUR FILES!

Be cautious and do redundant backups before migrating libraries.

KEYBOARD SHORTCUT

Hold down the **M** key to see the unedited version of a photo.

Reviewing Your Application Preferences

On your menu, open Preferences, and under the General tab you'll see Library Location at the top. This shows you where the library you have open resides on your Mac. If it's a secondary library, you have the option to make it the System Photo Library by clicking on the Use as System Photo Library button. (If you don't have any secondary libraries, this button will be grayed out.) When you click on this, you'll see a warning about what will happen with your existing iCloud content. Generally speaking, you do not want to change your System Photo Library unless it's part of an overall strategy.

The next option is Summarize photos. I think this box should be checked because it's really how Collections and Years work effectively. I know we haven't discussed those yet. So for now, leave that box checked.

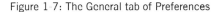

Figure 1-7: The General tab of Preferences

A new feature as of Photos 2.0 is Memories. And in Preferences, you have the option to show holiday events. I say, why not? If it starts to drive you crazy, you know where to turn it off.

Copy items to the Photos library should also be checked. This is the option to run a managed library, which is the default where the masters are stored inside the library container. If

you uncheck that box, then subsequent imports will be stored outside the container, thereby creating a referenced library. For now, unless you have a plan, leave this box checked.

I'm going to argue that you uncheck the box for Include location information for published items. I think publishing the location information that iPhones and iPads gather when taking pictures

Figure 1-8: The iCloud tab is only available for the System Photo Library. This is how I have mine set up. I'll go into more detail about this in chapter 8.

should be something you do on purpose, not automatically. We don't always want strangers to know where we live or where family members and friends reside.

The Reduce motion option for the user interface is based on personal preference. I think the motion in Photos is fun.

There's another tab in Preferences for iCloud. It's only active for System Libraries. I talk a lot about iCloud in chapter 3. But for now, if this is your System Library, I recommend checking all the boxes in that tab.

Approach to Library Management

My System Library is the one I depend on. Because of its iCloud connectivity, the images there are available on all of my Apple devices. I do have a few secondary libraries for special projects. But I try not to make a habit of having too many Photos containers on my hard drive.

This brings up the question of what to do with existing Aperture and iPhoto libraries. If your tests go well, I don't see any reason why you shouldn't migrate them as secondary libraries. It's easy to switch back and forth, and those pictures will be available to you as Mac's operating system evolves in the future.

I'm hesitant to recommend that you start out by making a large Aperture or iPhoto library your System Library in Photos, unless it's already happened automatically. This could lead to the need to buy extra disk space, plus things could get a bit messy in Photos as a result of the migration. Such clutter could dampen your enthusiasm for using the app. We're only in chapter 1, after all. I don't want to lose you yet!

For the moment, I recommend taking the path of least resistance. Let's work with the library you have open. As you gain experience, you can decide what to do up the road.

Finding Your Way Around

The thing I don't like about change, such as learning a new app, is that it's disorienting. I feel a little lost. Being a guy, I already have the disadvantage of not being able to admit when I'm not exactly sure where I am. I have to act like I know what I'm doing when sometimes I don't. It's uncomfortable, but those are "the rules."

My typical plan is to figure out where I am before anyone discovers that I didn't know in the first place. It's a lot of work, really.

So my goal is to save you that effort, especially for the guys reading this. I want you to know your way around Photos for macOS without having to fake it. Together, we're going to learn where the important things are, so no one has to admit anything.

The First Time I Saw Photos

A while back, I joined the public beta program for Mac OS X Yosemite just to see Photos. It was added to Mac OS X 10.10.3. I installed it on a Mac, looked around a bit, and then thought, "That's great. Where's the rest of it?"

Have you ever received a gift that you thought was just the setup for the real gift? But it wasn't. Let's say that you unwrap the box and there's a handsome key fob inside. You're thinking, "Oh, that's nice. I bet the next gift has a key to go with it. Maybe a key to a new car!" But there is no next gift. You got a key fob, and that's it.

If I were to describe how I felt the first time I opened Photos for macOS, I would say key fob comes to mind. But there were two important things I didn't know at the time. First, looks are deceiving. (Actually I do know that, but I forget sometimes.) There was a lot more to this application than I initially realized. Second, editing extensions were not a reality yet. And their emergence with Mac OS X El Capitan made a huge impact. We'll learn about those in chapter 7.

For the moment, I want to show you around Photos. And despite my initial impression, I have to admit: it's not just a key fob after all.

Top-Level Navigation

Open the application. Chances are good that you already have some pictures inside. Photos is good at tapping into iCloud and converting iPhoto libraries.

If you don't have any pictures in your library, you need to add some now, or this part of the book won't make any sense to you. So take a look at the sidebar: How to Import Pictures from a Memory Card.

The Photos Tab

I need to warn you that I'll be writing the word "Photos" a lot. This is because Apple named this application "Photos for macOS" and labeled the first tab inside the software the same thing. If they would have asked me, I would have named the tab Pictures. But they didn't.

Regardless, the starting place for our adventure is the Photos tab. It's positioned near the top of the interface and has white letters on a gray background. (It's only this way when you're working there. Otherwise it's black letters on a white background.) The Photos tab supports three different thumbnail views: Moments, Collections, and Years. Moments is the most intimate view. You're right there with your images, with a name for their location (if it's available) and the date they were captured positioned above the pictures.

HOW TO IMPORT PICTURES FROM A MEMORY CARD

With Photos open, connect your camera via its USB cable, or insert its memory card into a card reader, such as the one in the side of a Mac laptop.

Photos will create a new tab called Import and will display the thumbnails of the images available for copy. If you want them all, click on the blue Import All button. If you want just a few of the shots, click on their thumbnails (this adds a blue check to them), and then click on the Import Selected button.

Do not check the box labeled "Delete items after import." For the time being, you want those pictures to remain on the memory card in case something goes wrong. So leave that box blank.

Once the import has completed, the images will be added under the Photos tab, as well as to the Last Import album in the Albums tab. Safely eject your card, and remove it from the device, or unplug the USB cable connecting the camera to the computer. The Import tab will now go away until the next time you bring pictures into your library.

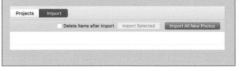

Double-click on any thumbnail, and you'll see a larger version of it.

Figure 2-1: Looking at the Moments view inside the Photos tab

Double-click again, and you're returned to Moments.

The flow of pictures in Moments is based on when the photograph was captured: the oldest stuff at the top, scrolling down to the newest images at the bottom. The more pictures you add to your library, the more scrolling you

ENLARGING THUMBNAILS

Double click on any thumbnail, and you'll see a larger version of it. Double-click again, and you're returned to Moments.

would potentially have to do. To alleviate this, you can take a step back and go to the Collections view. Do so by clicking on the left arrow at the top of the interface or by pinching on a trackpad. (By the way, the trackpad gestures are really fun. I highly recommend them for laptop users and those with plug-in trackpads.)

The application gathers groups of Moments together to create these Collections. The thumbnails get smaller, and you can navigate from top to bottom faster. If you want a closer look at any of these thumbnails—perhaps because it is too small—then

Figure 2-2: The Years view inside the Photos tab

click and hold on one, and a popup version of the image will appear. Let go of the mouse, and you'll be taken to the viewer with that picture featured. Double click on it to bring it back to thumbnail size.

On a trackpad, after you're finished looking at the picture, pinch once to go to Moments and then pinch again to return to Collections. You can also use the back arrow button to do the same thing. Over time, this becomes very natural, especially for laptop users who can pinch in to go backward and pinch out to go outward.

From Collections, you can go back one more step to the Years view. Here, pictures are gathered into yearly groups, and the thumbnails are really small. The same tricks work as they did in Collections. Click and hold to see a larger version of a picture. Pinch outward, or use the forward arrow to move to Collections. And when you pinch outward, wherever your mouse pointer is placed is where you'll be taken to in Collections. Nice maneuver!

Let's put this into practice. Say you want to find a photo from your vacation in Hawaii. I don't recommend that you

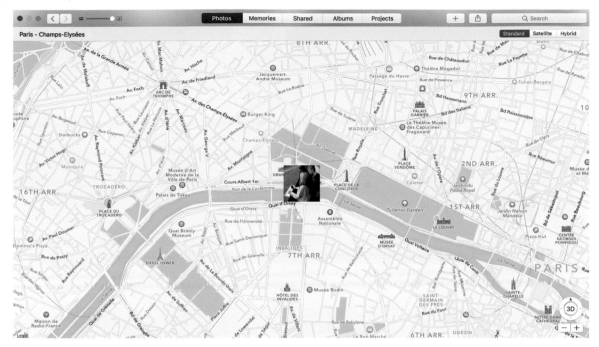

Figure 2-3: Click on the place listed at the top of a Moment, Collection, or Year, and Photos will direct you to a map showing where those shots were recorded

scroll endlessly though Moments to look for it. Go directly to the Years view, and mouse over the general area in the particular year you went to Hawaii. Pinch outward to go to Collections. Find the Collection that has your vacation in it, and pinch outward again, or use the forward arrow. This should bring you very close to the image you're looking for.

This procedure is one of the first features of Photos that users tend to overlook. Some folks think that they're destined to scrolling endlessly though Moments every time they want to find a

shot. No! If you know the approximate date of when you took the photo, work upward through Years and Collections to find it. It's much faster.

To this point, I've been focusing on time. But when available, places are displayed at the top of each Moment, Collection, and Year. If you click on that name, Photos will take you to a map that shows where the picture or pictures were captured. If you shoot with an iPhone, you'll see a lot of these locations in your library because these devices record location information with every

shot you take. Some digital cameras have this capability too, but generally speaking, your iPhone will be the biggest contributor to adding geodata (where pictures were taken) to the Photos library.

Before we go any further, I just have to say I love this feature. For example, I had a great time in Paris with my family. I have a picture of my wife and boy figuring out direction in the heart of the city. When I go to Map view in Photos and see exactly where they were standing, with all of the iconic landmarks around them, those good memories seem as fresh as the day I experienced them.

This is one of the reasons I take a lot of pictures with my iPhone. Yes, I am a serious photographer, and I do use serious-looking cameras, even on family vacations. But I also use my iPhone a lot, in part because I enjoy seeing those pictures on a map.

I discuss metadata in chapter 4, where I'll show you how to add location information to images that were not recorded with geodata. So even if you don't use an iPhone or similar device, you can still have a blast with the Map view.

OK, back to finding our way around. You can zoom in by pinching, using the scroll wheel on your mouse, or via the + and – icons in the lower-right corner. Click and drag to move the map around. Double-click on any of the images to see a larger version.

The upper-right corner of the map offers you three views: Standard, Satellite, and Hybrid. Generally speaking, I stick with Standard. But sometimes the other views are fun if you really want to relive the experience. Click on the back arrow button when you're finished to return to the previous view.

Wasn't that fun? It's like taking a trip without leaving the sofa.

The Top Toolbar

Before we leave the Photos tab, let's take a look at the top toolbar. Starting on the left side, the back and forward buttons help you navigate through Moments, Collections, and Years when in the Photos tab. The zoom slider controls the size of thumbnails. And the five navigation tabs take you to different parts of your library. We've already explored the Photos tab. I'll also explain Memories, Shared, Albums, and Projects. This is also where the Import tab appears when you connect a camera to your Mac.

While in the Photos tab, in the right side of the toolbar is the Add button marked with a + icon. Click on it to create Albums, Smart Albums, Books, Calendars, Cards, Slideshows, and Prints. Yes, we will get in to all of that.

The Shared button is between Add and the Search box. Depending on the services you have enabled on your Mac, a variety of options can appear

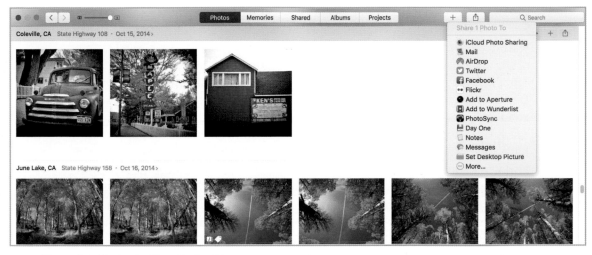

Figure 2-4: The top toolbar with the Share popup menu showing

in this popup menu, including Twitter, Facebook, and Mail.

On the far right is the Search box. This is where you can search for specific photos by entering text, dates, and even names. It's very powerful.

The Memories Tab

If you've upgraded to macOS Sierra, then you automatically have Photos 2.0 and you can see a new tab at the top of the interface labeled Memories. Click on the tab, and you will be treated to a visual tour de force of your past.

At the top of the page there may be a scrolling slideshow of an event from the previous year. Beneath that are actual images from that "memory," plus their location on a map if the images were geotagged. Depending on the depth of your Photos library, there may be related Memories below that.

How does this all happen? Apple has incorporated new, intelligent algorithms into the application that analyze your images based on a set of categories, such as day in history, location of interest, and special events. The results of that analysis are pulled together as Memories.

I'll talk more about this in chapter 4. This is a highlight feature in version 2 of Photos, and it was designed to assist you in finding important images in your ever-growing library.

The Shared Tab

As you continue to move from left to right across the tabs, Shared is next in line. Here's where you can view

albums you've shared with others via iCloud Photo Sharing—and if they want to return the favor, the albums others share with you show up here too. I'll spend more time talking about this area when I cover iCloud in chapter 8.

But the top story here is that if you have friends and family members who also use iCloud, this is an easy way to share collections of images with them. You simply create an album, click on the Shared button in the toolbar and choose iCloud Photo Sharing, add the email addresses of those whom you wish to have access, and that's it. As you add images to a shared album, everyone gets an update with the new pictures.

To make this even better, there's a Shared tab in the Photos for iOS app. So the images are available for viewing across all Apple devices, such as iPhones and iPads.

As I mentioned earlier, I'll dig deeper into this when I cover iCloud in chapter 8. The ability to share images so easily is a strength of Photos for macOS. So unless you're the only person in your sphere who has an iCloud account, this is probably a feature you'll want to learn more about.

The Albums Tab

I think this is one of the most useful areas for organizing your image collection. Yes, the Photos tab is clever, and it works well. But for those of us who like to create our own groupings, Albums is the place to be.

I really dig into this area in chapter 4 when covering organization. But I'll give you a taste of things to come. This tab is divided into two basic areas: the Albums that Photos for macOS creates, and the ones that you have control over.

The automatic albums are for things such as Last Import and All Photos. All in all, there are about twelve potential categories here. And they are populated for you as you go about your work in the application. So, if you bring in pictures from a digital camera, that session is available in Last Import. Panoramas captured with your iPhone are automatically added to the Panorama album. This is the "I don't have to do anything" approach to organization, and it's pretty nice stuff.

Below the automatic Albums is the My Albums area. Here you can create your own collections, build Smart Albums, and arrange things in the order that you want. And if you go album crazy and create too many, folders are available too. Create a new folder (File > New Folder), and then stuff it full of albums. A folder is like a hall closet for your picture boxes.

How you leverage these options depends on how you like things

organized. I can see some folks being perfectly fine with the Moments, Collections, Years structure in the Photos tab. I use it all the time myself. But, as you can see from figure 2-5, I like Albums too. They help me think.

If I want to concentrate on a group of pictures, putting them in an album and moving them around inside to my liking helps me think about how I want to edit and share them. Albums reduce the noise. And they don't have to be permanent. You can create a tempo-rary album just for an editing session, if you wish, and then delete it when you're finished. Deleting an album does not delete the pictures inside of it. They still live in the Photos tab. How could you not like this feature? We'll continue this conversation in chapter 4.

> **YOUR PICTURES LIVE ON**
>
> Deleting an album does not delete the pictures inside of it. They still live in the Photos tab.

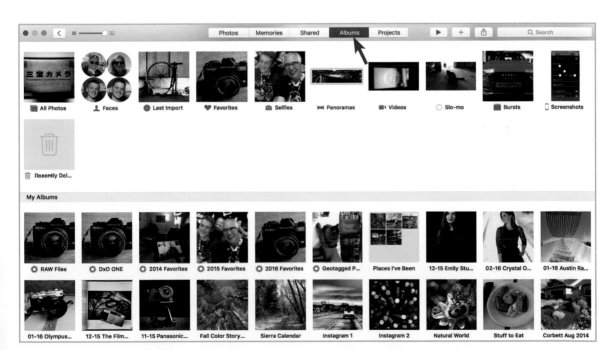

Figure 2-5: For those who like a little more control over organization, the Albums tab is very useful

The Projects Tab

Every time you create a slideshow, book, calendar, or greeting card, Photos keeps track of it in the Projects tab. Once again, you just have to focus on the project itself, and Photos will do the rest.

Now I just have to ask you this: Have you ever dreamed of having someone like Alfred in the Batman series working for you? You know, the really smart, helpful, wise person who keeps you from running off the rails. I have, although I doubt there will ever be an Alfred in my future. If there were, I would want Michael Caine. And I'm pretty sure he isn't available.

The reason I bring this up is because there are times when I feel like the spirit of Alfred is in Photos for macOS. The way it sorts my pictures for me and keeps track of my projects is really helpful. And as we'll discuss later

on, it even backs them up to the cloud for me.

This is probably as close to Alfred as I'll ever get.

So along those lines, one of the things I like about this project management is that if I want to go back and work some more on a slideshow or book at a later date, it's waiting for me. I double-click on it and pick up right where I left off. Alfred couldn't have done better himself.

Interestingly enough, I rarely start a project here. I usually create an album first in the Albums tab, click on it, and then choose the project I want to initiate from the popup menu in the Share button. Why this way? Well, it's a lot easier to pull together the images you want in an album and then create a project than it is to start with a blank project and go hunting for the pictures. This may seem like an inconsequential

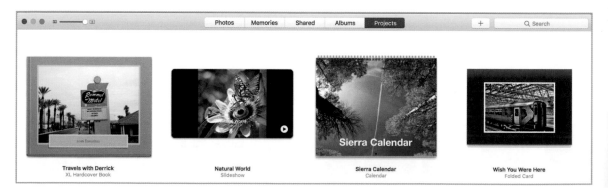

Figure 2-6: The Projects tab is where my books, slideshows, calendars, and greeting cards are managed

difference, but trust me, this is one of the tips you'll thank me for.

STARTING A PROJECT

When starting a new project, create an album first in the Albums tab, click on it, and then choose the project you want to initiate from the popup menu in the Share button.

The Menu Bar

At the very top of the screen is the menu bar for Photos. I saved this for last for a reason—because in the next chapter we're going to move from learning where things are to arranging them in a manner that's pleasing to you. The menu bar is a key player in this activity.

For now, I'll say this: If you can't find a function through the standard Photos interface, take a look up here. Almost everything Photos can do is located at the top of your screen.

And I'll close with a final tip. Under Help in the menu bar is Keyboard Shortcuts. These are real timesavers. I'm sure you already know that individual keyboard shortcuts are listed in the menu items. So, for example, if you go to Edit > Paste, you'll also see the shortcut Command-V.

The thing I like about the entire list of keyboard shortcuts under the Help menu, is that you can print them out and keep them by the computer as you master your Photos experience.

OK, time for a break. Then we'll move on to "making it yours" in the next chapter.

3

Make It Yours

Photos for macOS supports a variety of viewing options and keyboard shortcuts. In this chapter I'm going to show you these options, enabling you to customize the app to your personal tastes. In other words, make it yours.

Customizing Your World

This might sound odd to you, coming from a guy writing a book about a computer app, but I love film photography. Part of the attraction comes from mechanical cameras with well-positioned buttons, dials, and click-stops to operate them.

So even though I have sophisticated digital cameras to accomplish my work and share images online, much of what I buy is used and often even decades old. I can pick up a manual-advance SLR body from one seller, a matching lens from another, and then search for the right strap, eyecup, filter, lens hood, and case. I also have to figure out what kind of film I'm going to put inside. Will it be my black-and-white street shooter, or is it better suited for vibrant colors and landscape work?

All of these decisions are an enjoyable part of the process. And once I've customized the camera, I can thoroughly immerse myself in the creative process of making photographs. My affection for the tools motivates me to go out and create the art.

This is why you have to make it yours. Earlier, I talked about Photos for macOS being the new home for your images. And that's what you want—a home, not a motel room where the TV is bolted to the table and questionable artwork hangs on the wall.

You can't do your best work under those conditions. One of my favorite Stuart Smalley quotes from *Saturday Night Live* is, "It's easier to put on slippers than to carpet the world." Isn't that great? Yes indeed. We can lament all we want about the stuff that isn't in Photos, or we can take a closer look at what's here.

I'm going to show you a few choices for customizing Photos for macOS, in the hope that you can make this app home sweet home for your pictures. It's not a stuffy motel room with dim fluorescent lighting. It's your home for photography. It's those comfortable slippers that feel good beneath the feet.

Figure 3-1: What is this? That doesn't look like my Photos app. Well, it can.

If we can achieve that, then I think you will do some of your best work ever, right here.

First, the Interface

I've already introduced you to the tabs on the top: Photos, Memories, Shared, Albums, Projects, and sometimes Import. They are good navigation tools, but there's another way to go.

Show Sidebar

On the menu bar, go to View > Show Sidebar. (You can also use the keyboard shortcut Option-Command-S to toggle on and off the sidebar.) The tabs at the top of the interface go away, and a sidebar appears on the left side. From top to bottom it lists Photos, Memories, Shared, Albums, and Projects. The main viewer area still displays the same Moments, Collections, and Years, controlled by trackpad gestures or navigation buttons.

Much of the same rules apply here as when you're in the tab view; namely, you can click and drag your albums in the order you want. But the albums created by the application stay where they are. If you click on the vertical line that separates the sidebar from the viewer, you can drag it to the left or right, making the sidebar wider or narrower.

Right-click or control-click on an album name, and a popup menu will

Figure 3-2: You can display your library's organization as a column down the left side

offer you a set of actions such as duplicating or renaming the album.

One advantage to the sidebar view is the collapsible folders that can store albums. Yes, you have folders too in the tab view, but they behave differently. (I talk about creating folders in the next chapter, but the bottom line is that you can create and use folders to minimize album clutter.) So instead of having 100 albums run down your sidebar, you can have four folders labeled with titles such as Events, People, Places, and Things, each with dozens of albums in them, that you can collapse and open as needed.

To create a folder, go to File > New Folder. Then drag your albums

Figure 3-3: Control-click to reveal a popup menu of additional actions

into it. Click on the tiny triangle icon next to the folder to open and close it. This structure works really well in the sidebar format. Here's a way you can organize your pictures:

Top-Level Folders: Years (such as 2014 Pictures, 2015 Pictures, 2016 Pictures)

Second-Level Folders Inside Top Level: Categories (Events, People, Places, Things)

Albums Inside Second-Level Folders: Any collection of images you want falling into that folder category.

So, if you have five top-level folders for the last five years of pictures, you can conceivably collapse all of your album collections into five containers that can be easily opened and closed in the sidebar. Again, more on organization in the next chapter, but this is good to know going into it.

Split View

In this mode you can have thumbnails displayed at the bottom of the interface with an enlarged version on the top. I particularly like Split View when

Figure 3-4: Now you can see your thumbnails below the enlarged image

ADJUSTMENTS Add

Histogram ˅

Light ˅

Brilliance

Exposure

Highlights

Shadows

Brightness

Contrast

Black Point

Color ˅

Reset Adjustments

Done

Figure 3-5: Split View is particularly nice while editing images

I'm editing a batch of photos, because I can move from one image to the next effortlessly.

This is how it works: With an image open, turn it on by going to View > Show Thumbnails. You can use the arrow keys on the keyboard to scrub through the thumbnails that now appear at the bottom of the interface. The horizontal line that separates the thumbnails from the viewer image is resizable, allowing you to make the thumbnails bigger or smaller.

At any time, press the Return key on the keyboard, and Photos will take you directly to Edit mode, changing the background from white to black. The Split View sidebar displaying your thumbnails will be on the left side and the editing tools on the right, with the enlarged image between them.

I recommend practicing the keyboard shortcuts for Split View, Sidebar, and the upcoming Full Screen mode. By doing so, you can quickly adapt your

Figure 3-6: Full Screen mode is helpful when editing. You can see the Split View thumbnails on the bottom and the editing tools on the right. Other than the picture itself, that's it.

viewing environment to your particular needs at the moment.

Full Screen Mode

At times you may want to hide the top menu bar and other aspects of the user interface to just focus on the image. Full Screen mode is designed for that, and I like it best when I'm editing pictures.

Turn on Full Screen by going to View > Enter Full Screen, or by using the keyboard shortcut control-Command-F. You can leave this view by pressing the Escape key or by using the keyboard shortcut again.

Just because the menu and toolbars have disappeared doesn't mean you don't have access to them. If you push your mouse pointer up to the top of the screen, they will appear so you can make your selection. Then, when the mouse drifts away from the top, they will hide again. This applies to the

dock on the bottom of the screen too. And you do have the option to show the toolbar in Full Screen mode by selecting it from the View menu.

Moving Things Around

You not only have some say in how the interface looks, but also can put things in their place by applying a few of the following techniques.

Sorting
Inside the albums you've created, you have some control over the order in which the thumbnails are displayed by choosing the sort option you want.

Figure 3-7: Oldest first? Newest first? It's up to you.

Sorting doesn't work for application-controlled albums, such as All Photos. But the albums and folders you create can be organized inside by going to View > Sort and choosing the option you want.

What's interesting is that you can move stuff around inside of your albums randomly by clicking and dragging thumbnails. I do this all the time when I'm working out a storyboard for a slideshow. I create an album specifically for the images in the slideshow and then drag them around until I'm satisfied with the order of the presentation.

So, technically speaking, you can organize your images any way you want inside an album. But then, after you've had your fun, you can restore chronological order to the thumbnails by using the Sort command.

Hiding Photos

I probably shouldn't tell you this, but every now and then I pull out one of the cigars I brought home from Cuba (legally!) . . . not to smoke it, but to photograph it. But cigars are not very popular around my house. We are definitely a nonsmoking family. So having those pictures in my Photos library isn't the best idea.

If I wanted to avoid an awkward explanation about these pictures, I could hide those photos. They're still in my library, but they won't show up in Moments, Collections, or Years.

You can do this too. First, select the images that you wish to remove from public view. Then go to Image > Hide Photos. The shortcut is Command-L. The application will remind you the images are about to be hidden but will still be available in the library. Photos creates a Hidden album and stashes those photos inside.

At this point, the images might be hidden, but the Hidden album will be visible in the Albums tab. It won't have a thumbnail, but it will be labeled as Hidden. That doesn't look suspicious at all, does it?

You can hide the Hidden album by going to View > Hide Hidden Photo Album. (This is feeling like a TV murder mystery, isn't it?) So now your images and the album they're in are removed from plain sight. So how do you get to them? Just go back to View, and select Show Hidden Photo Album. You can now see all of the pictures inside.

After the coast is clear, you can unhide any of the images in the Hidden album by selecting them and choosing Image > Unhide Photo. Whew! That's a lot of work. I think I'll just avoid taking pictures of my Cuban souvenirs. It's easier that way.

Zooming

Getting a closer look at your work is easy in Photos. My favorite method in viewing mode is to place the mouse pointer over an area in the picture that

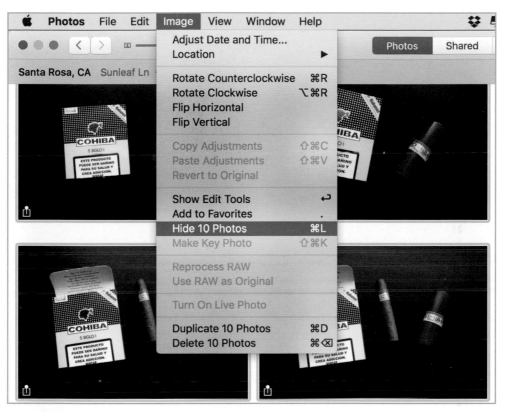

Figure 3-8: I don't want these pictures displayed in my Moments, Collections, or Years

Figure 3-9: Hidden album displayed with others

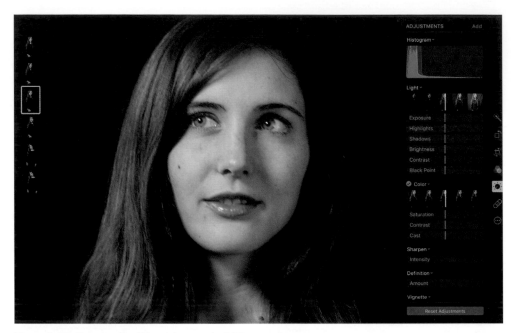

Figure 3-10: Pressing the Z key takes you to 100 percent zoom

needs closer inspection and then press the Z key. Photos zooms in on that spot at 100 percent. If you need to move the picture around in the frame, click and drag into position. When you're finished, press the Z key again to return to normal view. It's fast, easy, and effective.

You can also zoom at different magnifications. The keyboard combination Command + provides incremental zooming in five stages, starting at 50 percent and working upward from there. To zoom back out, use Command –. And just like working with the Z key, the location of the mouse pointer dictates the area that is enlarged.

Z IS FOR ZOOM

Point your mouse to an area you want to zoom in on and simply press the Z key. Press it again to return to original size.

ONE-TOUCH EDIT MODE

When viewing a single picture in Photos for macOS, you can send it to Edit mode by simply pressing the Return key. Press the Return key again, and you're back in viewing mode.

Hovering and Such

Over the months I've been talking about Photos for macOS, I've received mail from my podcast audience and others about hidden toolbars and other features. Most of the time I would say that a quick trip to the menu bar will solve the problem by choosing a different option in the View menu.

Keep in mind that hovering the mouse pointer over areas such as the thumbnail of an image might also reveal something, such as the Favorite icon or the title to the picture.

If you're a veteran Mac user, don't be afraid to guess. You have been feeding your OS X intuition for years, and you might be surprised how often this pays off when learning Photos.

Getting the House in Order

My hope is that you're getting more comfortable in Photos with each page you read. If you don't already have a library brimming with pictures, now would be a good time to add some more. You're now ready for the next chapter, where I'll delve deeper into organization. See you there.

4 Organizing Your Images

When you first look at your Photos library, most of the housekeeping appears to be handled by the app. That's on purpose. The idea is to let you focus on taking pictures and let the software keep track of them. The problem is, if you don't probe deeper, that one man's tidy garage is another man's black hole. Organization is a personal journey.

I remember when a friend came to my apartment when I was going through a rough patch with work and had more time on my hands than I normally would. I had spent a lot of that time cleaning and organizing my place.

When he walked in the door, his eyes surveyed my one-bedroom home. After a few moments, he said, "Man, this place is really clean. I mean *scary clean*." He was visibly uncomfortable there.

I quickly shuffled us both out the front door and on to our appointment. But I'll never forget the expression on his face. What I had envisioned as a tidy, organized abode was far too sterile for my friend. After a while, I got a full-time job, and my place returned to normal (but was still relatively tidy).

I think that's the complaint many first-time users have with Photos for macOS. Not so much that it's too clean, but that it appears too single-minded in its approach to organization. Some photographers like adding star ratings and color labels to pictures to help them sort and catalog. They feel more comfortable if each photograph has been inspected and labeled.

For those types, the flattened structure relying primarily on metadata just isn't their slice of pizza. And I can understand that. So, what I'm going to do in this chapter is help you understand the Photos approach and then show you a few alternatives for library organization. A big part of the process is understanding what Photos is doing on its own. Then we can explore the options we have to augment that.

Figure 4-1: How one organizes is a personal preference

After all, your image library is your home for memories. We need to make it as comfortable as possible.

Default Organization in Photos

As I previously mentioned, Photos relies heavily on the metadata provided by your camera and iPhone to organize its library. Images captured with a digital device will be grouped chronologically by date and will include location information, if it's available. We refer to these groupings as Moments.

iPhones are adept at identifying the time, date, and location at the moment of capture. Those places are shared with the application and displayed alongside the dates in the Photos view. (The *Photos* view? What is that? Click on the Photos tab at the top of the application interface. Now you're there.) Other cameras you use may not record geotags, but they do capture the time. That's why Photos uses dates as a primary way to organize. The date is one piece of information recorded by all digital devices.

Time, location, shutter speed, aperture, white balance, and other settings

Meadview, Kingman & Peach Springs · Jan 28, 2016

Figure 4-2: The Moments window in Photos for macOS

also fall into this category known as *EXIF data*. This data is hidden away in the file header of every digital image. If you double-click on a picture to enlarge it and then click on the i button in the upper right corner of the interface, you'll open the Info display that reveals much of this data.

Photos mines EXIF data to automatically organize your library by date. Bottom line: Photos is very good at understanding date and time.

Here's a quick test to prove my point. Enter a month and a year in the search box in the upper right corner of the interface, such as August 2015. Then hit return. Instantly, the application will display all the images that have that month and year in their metadata. So, if you know when you took a picture you're looking for, you're standing in tall cotton; Photos will lead you right to it.

Clear the search field, and click twice on the back button (looks like a less-than symbol in the upper left corner of the interface). The application will compress time for you. All of your images will become tiny squares displayed neatly beneath a header showing the year. 2012, 2013 2014, 2015 . . . they're all there. This is called the Years view.

Now click on the forward button, and the thumbnails get bigger and you're looking at smaller chunks of time. This is the Collections view. Click on an image again, it gets a bit bigger,

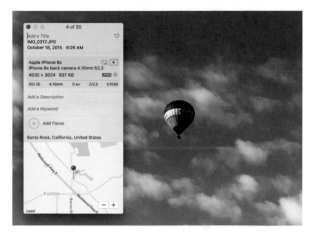

Figure 4-3: You can see the EXIF data for any image by opening the Info box: Window > Info

CLICK AND SCRUB IN YEARS VIEW

Those thumbnails are so tiny in the Years view. How are you to know what is what? The answer is click and scrub. Click and hold on any area in the Years view, and that tiny thumbnail will pop up as a bigger image. Now scrub to the left or right to see the images that you're curious about. When you find the one you want, let go, and Photos will take you to an enlarged view of that picture (Photo Viewer) for closer inspection or editing.

and the slice of time gets smaller. You're now in the Moments view.

You can also go from Years (smallest thumbnails) to Moments (biggest thumbnails) just by clicking on any area in the Years view. That will bring you to

Figure 4-4: Use the Years view for a 30,000-foot view of your Photos library. Notice the flower image is popping out. I'm clicking and holding on it.

a Collection. Click again, and you're in a Moment. Laptop users can pinch and zoom via the trackpad to move in and out as well. So if you have a trackpad, you don't need to use the buttons at all.

This is the heart of chronological organization in Photos, and I encourage you to give it chance. Sit down with your library, and navigate from Years to Collections to Moments. Use the back and forward buttons, pinch and zoom, and even click and scrub.

We're not really used to thinking about our image libraries in just this

OBJECT SEARCH

The latest version of Photos is pretty good at identifying objects as well as people. And you can use this ability to search for pictures in your library. Type the word "car" in the search box and click on the category result from the ensuing popup menu. You'll be presented with images containing autos in them. I've also tried "cat," "bike," and "ocean." Very handy. No keywords are required. And your life just got a bit easier.

way. I think I can speak for many of us in that we like to put things in boxes. We tend to be uncomfortable with one giant box filled with all our pictures. But that's what Photos does. And it does so intelligently. Keep an open mind, and play with it. You might be surprised.

Albums and Folders

Beyond what Photos does automatically, we can enhance organization using albums and folders. If you click on the Albums tab (again, at the top of the interface), you'll see there are three basic types available: albums that the application automatically creates, albums that we make ourselves, and smart albums. And if we wish, we can create folders to keep the albums in. (Stick with me here. We're just getting warmed up.)

Using these tools doesn't negate the application's system of Years, Collections, and Moments; rather, these are complements to the existing structure.

Keep in mind that albums are virtual collections. You can add images

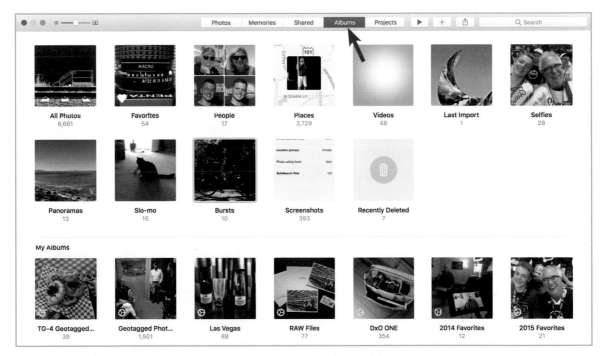

Figure 4-5: As your library grows and you organize more, the Albums tab will become more populated

to them, delete shots, and move them around; yet these actions don't affect the underlying structure of your library. So if you delete a picture from an album, it's still in your library. It's just not in your album.

When you think about it, that's very handy. So let's take a closer look at this organizational tool and explore how to use it.

Application Albums

The more I use Photos, the more I've grown to appreciate this top area of the Albums tab. The software identifies certain types of pictures and then automatically puts them in an album of like kind. There's not much here for you to do other than sit back and enjoy the show.

These categories include Selfies, Panoramas, Videos, Slo-mo, Bursts, and Screenshots. You won't see these specialized collections unless you've captured that type of shot with an iOS device. Once you do, the album is created and populated. They're all nice, but I think the most useful of the auto-created albums are All Photos, People, Places, Last Import, and Favorites. They demand a closer look.

All Photos is similar to Moments in the Photos tab, except that it isn't divided into events. It's a flat

Figure 4-6: Photos for macOS populates this area for you, depending on the types of images you have in your library

presentation of all the images in your library, sorted by date.

People uses facial recognition to help you identify the people in your library and then gather them together in their own collections. We'll talk about Faces a bit more later.

Last Import is really helpful when you want to review the images recently added to the library via the import command. So if you copy 100 shots from your DSLR, they will all be there in this album. You can then review them and mark favorites without being distracted by other existing photos.

Favorites displays the images you've marked as such. If you have a lot of favorites, this album can become quite daunting. This is where some photographers pine for star ratings to help them distinguish between a super-favorite and a so-so favorite. We can fine-tune this a bit with Smart Albums, as I will show you soon.

Albums You Create

Let's say you're browsing your Moments and notice a group of photos that you'd like to save in an album. You can do that, and the collection will be stored in the My Albums area of the application. Once you have those pictures in an album, you can organize them any way you want inside that container. That's

why people like albums. Here's how to create one:

1. Identify a group of pictures, and select them.
2. Click on the + icon in the top toolbar.
3. Select Album from the popup menu.
4. Create a new album and give it a name, or add the pictures to an existing album that is listed in the dropdown menu.
5. Click OK.

You'll find your new creation in the My Albums area. You can choose its key photo by opening the album, clicking on the picture you want to identify the collection, and then control-clicking on it and selecting Make Key Photo from the popup menu.

Organizing the My Albums Area

Over time, your My Albums might become overpopulated. But you have options to organize it. You can rearrange the order of the albums and create folders to store them in.

To move an album, just click and drag it to a new position. The other albums will move over to make room for it. If you decide that you want to delete an album, you can simply by

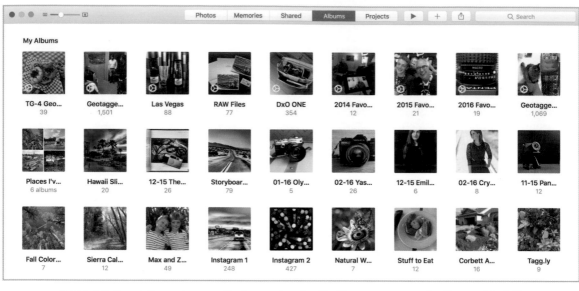

Figure 4-7: Depending on how you like to organize, the My Albums area can get quite populated. The top row of mine has all smart albums (see the gear icons). The second row starts with a folder on the left, and the rest are regular albums that I created.

using the control-click command on it and then choosing Delete Album. Apple will remind you that your pictures will still remain in your Photos library. I find those reminders comforting.

When you have many albums of the same type, such as holiday photos, you may want to put them into a folder. This helps reduce clutter in the My Albums area and makes it easy to browse images of a like kind.

You don't access the new folder command via the + button, as you might have guessed. It's not there. But you can find it under File > New Folder. This action behaves much like creating a folder in the Finder. The application places an empty container in the My Albums area labeled as New Folder.

Alternatively, you can right-click in the open area of your My Albums window and then select New Folder. Give your new folder a name, and then you may drag the albums you want to store inside the folder.

The empty folder icon is replaced with little thumbnails representing the albums inside. Double-click on the folder to open it. There are the albums! If you decide to remove an album from this area, control-click on it, and choose "Move Album Out of . . .", and it will be relocated to the top level of the My Albums area. If you ever get lost and forget how to get back to where you were, you can click on the back button or just change tabs.

One thing you should know about folders: If you decide to delete one by control-clicking on it and choosing Delete Folder, all of the albums inside will be removed too. Your pictures are safe, but the albums will go away. So remove the albums from the folder before deleting it.

Smart Albums

There may not be star ratings or color labels, but thank goodness there are Smart Albums. With a little creativity, you can automate a great deal of organization.

You can initiate a new Smart Album by going to File > New Smart Album, or by choosing it via the + button popup menu. Either way, you're greeted with a dialog box that allows you to name your album and configure the first condition.

There are three basic components to setting up the condition. First, on

the left side, is the item. This could be a photo, date, filename, ISO rating, and other things included on the popup menu. Next is the "is" or "is not" action. This popup can vary depending on the item, but its basic function is the same. And then on the right side is another group of options such as RAW, referenced, tagged with GPS, and others.

If you want to find all of the images in your library that contain location data, you would choose Photo : is : tagged with GPS. Photos will immediately indicate how many images in your library meet this condition by listing the number of matches. In my case, it's over 2,000.

What if I want to narrow that down a bit? I could by adding another condition. In the Smart Album dialog, click on the + icon that's surrounded by a circle, and another set of options appears. This time choose Date : is in the range : 1/1/2015 to 12/31/2015. Adjust the title to "Geotagged Pictures 2015." Then select

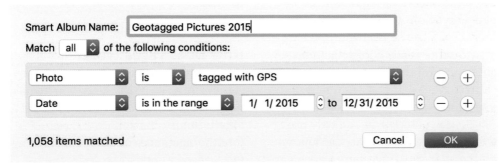

Figure 4-8: Here's the setup for a Geotagged Pictures 2015 Smart Album

match "all" of the following conditions. The results number will be adjusted to the new settings, which is 1,058 in this case.

Click OK, and Photos will create the new Smart Album and will open it for you. Click on the back arrow, and you'll be returned to the My Albums area where you will see your new Smart Album. You can drag your new Smart Album to any position you want. I tend to keep mine at the top of the My Albums area.

One of the quirks about Smart Albums is that you don't get to select the key photos. So what you see is what you get. You can, however, edit its conditions. If you decide you want to see all the geotagged pictures from 2016 instead of 2015, control-click on the Smart Album icon, and choose "Edit Smart Album" from the popup menu. The conditions dialog box will reappear, and you can make the necessary adjustments.

Photos allows you to have up to 12 conditions for a Smart Album. You can also delete existing conditions by clicking on the – button. You can create some really cool collections, such as Smart Albums for particular cameras, ISO settings, focal lengths, and more.

So, even though we can only use the favorite tag to indicate our love for a particular image, we can create a variety of Smart Albums that organize those

favorites by various criteria. This helps us fine-tune our rating system.

Smart Albums have always been helpful tools. In Photos for macOS, they are vital.

Using Faces to Help Organize a Library

Many of us take a lot of people pictures. Photos allows us to tag these images and draw these folks together into collections. This function is called Faces.

Photographers have had a love/hate relationship with Faces in its previous incarnations in iPhoto and Aperture. They loved the concept but hated the performance. If you fall in to this category, keep an open mind as we explore Faces here. Apple has rewritten its facial recognition capability from the ground up, and it performs much better now. I think the real question is: will you find it useful? Let's find out.

How Does Faces Work?

Here's a brief overview. Once you add a name to a picture of a person in your Photos library, the application searches for other instances of that person (using facial recognition) and collects them into an album. So, instead of having to

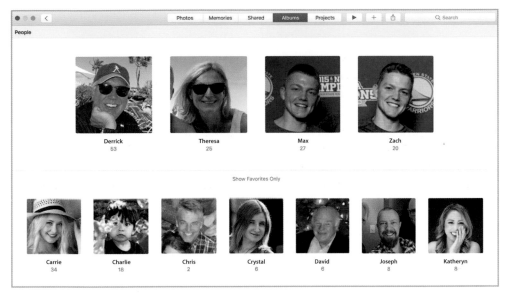

Figure 4-9: Faces are now collected in the new People album, under the Albums tab

hunt through your entire collection of photographs for a great picture of Aunt Sally, it should be right there in her Faces album.

As your library grows, so will the number of people you could potentially identify. Keep in mind that you only have to create Faces albums for the people you want. You can add more people to the album by clicking on the Add People icon at the bottom of the page.

Before We Move Forward

I have two face recognition anecdotes that you might enjoy before we get to work. The first is related to my twin boys. They're not identical, but most

people can't tell them apart at first. And by people, I also mean Photos.

So each boy is included a few times in the other's Faces album. You can imagine how delighted they are about this. After spending their lives being called the wrong name half the time, they now learn that technology can't distinguish between them either.

The moral of this story is: the facial recognition in Photos is good, but certainly not perfect. Check your work, and delete look-alikes as needed.

This sort of confusion is not limited to human beings, however. Here's the second story. I sometimes like to have two eggs and a slice of toast for breakfast. My eggs come from a farm here in town, and each dozen features various sizes and colors. I'm so used to this that

a carton of all-white, same-sized eggs looks a bit scary to me.

One morning I cracked open the second egg, and it had a double yoke. "Wow," I thought, "that's cool." So I took a picture of it with my iPhone to post on Instagram (my account is DerrickStory, if you like this type of high art).

Well, since it was an iPhone shot, that meant is was automatically added to my Photos library. So you can imagine my delight when I opened my Faces album the next day and saw a new candidate to identify.

Yes, you guessed right. My frying eggs were there waiting to be named.

The moral of this story is: you never really know what's going to show up in your Faces library, human or otherwise.

Adding People to Your Faces Album

OK, eggs aside, let's get to the real task at hand. We'll start by clicking on the Albums tab at the top of the interface. If you have human beings in your Photos library, their faces should be in the People album waiting for you. This is one of those automatic albums I talked about earlier. The minute Photos identifies people in your library, it will create a People album for you. And if it misses a few folks, that's OK: you can add them yourself. More on that later.

To get started, double-click on the People album to open it. In the next window, you'll see thumbnails for the people that Photos has recognized, plus a blank thumbnail with a plus sign that's labeled, "Add People." You can add a name to a thumbnail by clicking on Add Name, which appears when you mouse over the person's face. Go ahead and type a name there.

Now double-click on the thumbnail to go to the next screen. Photos takes you to the Summary view. But you can see all of the images by clicking on Show All (the type that's in blue). Here's where you can do a bit more work.

You should see: Confirm Additional Photos, Favorite this Person, and Add to Memories. If Confirm Additional Photos is grayed out, that means Photos thinks it has captured all instances of that person. If it's in blue, then you might have more folks to confirm or deny. Click on it, and Photos will ask you about the people in question, allowing you to say yes or no. Once you've finished with that, click the Done button.

For people who you've been photographing over the years, you'll probably have to identify their face many times in different instances. However, once you identify a photo with the name, it is added to that person's album with the other existing shots.

There are two additional buttons in the upper right hand corner: Photos and

Photos | Memories | Shared | **Albums** | Projects ▶ + ⬆ Q Max ⊗

People
18

Places
3,746

Videos
48

Last Import
1

Recently D...
3

Max and Zach
Album — 49

Max Hedges
Person — 25

Max
Filename — 12

Max
Keyword — 1?

boys **Max**
Keyword — 3

Max
Description — 2

Figure 4-10: I found another photo of Zach that the application didn't initially recognize. So I can add it myself. Notice how Photos offers an auto-completion.

CHANGE THE FACES KEY PHOTO

When you first identify a person and Photos creates their Faces album, the application also chooses the key photo. Sometimes it chooses well, other times not. But you can change that.

Open any Faces album, and browse the different shots of the person inside. When you find one that is the perfect image to reflect their collection, control-click on it, and choose Make Key Photo from the popup menu. That image will now represent the entire collection.

Get Info

Show in Moment

Rotate Clockwise

Turn On Live Photo

Duplicate 1 Photo
Play Slideshow
Share ▶

Hide 1 Photo
Delete 1 Photo

Theresa Story is not in this photo
Make Key Photo

Figure 4-11: You can change a person's key photo by control-clicking on their face and selecting Make Key Photo from the popup menu

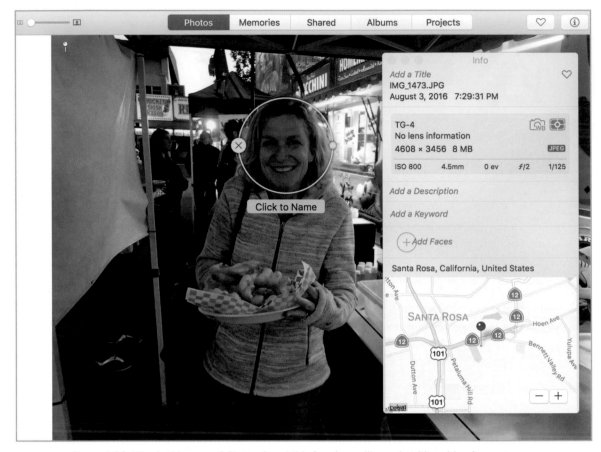

Figure 4-12: Who is this person? Photos found this face in my library, but it's waiting for me to identify her

Faces. These allow you to control the views of the thumbnails. Photos shows the entire picture in the thumbnail, and Faces zooms in on the face itself, presumably to make it easier to identify the person.

To add a person that Photos has overlooked, click on the Add People button that appears at the end of the line of identified thumbnails. Photos will take you to a Select People window where you may click on the face of the person you want to include. Once they are highlighted, click on the blue Add button. That person will be added to the row of existing folks, where you can add

their name and verify other instances of their visage throughout your library.

A Person's Life Before Your Eyes

This area of Photos illustrates how the use of technology can lead to an experience. We're not just looking at a person in your library. We're seeing them in the context of their life and with those they've lived it with. It's rather incredible, and it's all put together for you in what Apple calls a Memory.

Let's start with navigating the People album itself. You'll notice there are big squares and smaller squares. If you don't have any big squares yet, don't worry. It just means you haven't established any favorite people yet. For me, the bigger thumbnails represent my inner circle of people, and the smaller ones are more casual friends.

You can also drag a little square up to the big squares to promote it, and vice-versa. The big square folks are represented on your People album icon at the top level of the Albums tab. So this honor is a big deal. You can also promote them (or demote . . . say, an ex-boyfriend?) by control-clicking on a thumbnail and choosing the appropriate action. And while you're in the People album, you can have just your Favorites viewable by clicking on the blue Show Favorites Only text in the middle of the page.

Figure 4-13: Once you've identified a person in Faces, they become a full-fledged member of search

When you double-click on any individual person, you're taken inside their world, and I mean that literally. There will be a running slideshow (with music if you click on the Play button in the toolbar) highlighting moments in that person's life. Below that, you'll see people who are related to the person followed by a gallery of images that feature the star of the show. But wait, there's more. How about a map of where the geotagged images from this person's life are plotted? Yup, it's there. And finally, you will find featured Memories of events that the subject participated in.

Wow. This is like one of those life-time tributes you would see at a retirement party. Get out the Kleenex. And if this is someone you're missing . . . well, be careful.

More About Faces

Beyond the Memory that Apple creates for you, having people in your library identified using Faces comes in handy in other ways too. At the top of the list is the Search function. If you start typing a person's name in the Search box in the toolbar, you're presented with the various ways they are described in your library, such as Memory, description, keyword, etc. Clicking on any of these options takes you to a page that displays the results.

You can add a person to their Faces page by displaying a picture they're in, and then clicking on the **i** button in the top toolbar. This opens the Info box where you can click on the Add Faces icon and name the subject of the image.

And finally, you can create Smart Albums that feature groups of people, such as your immediate family. Just create a condition for each member (Person > Includes > [Name]) and select "any" from the Match popup menu. The cool thing about Smart Albums is that they grow as new images meet the conditions.

As I think back on the first iterations of Faces in iPhoto years ago, I'm impressed with the evolution of this technology. Yes, it was fun in the early days, but now, when combined with the power of Memories, the People album becomes a special place that features those who are important to us. Not only have we gathered images of the people, but we see them in the context of their lives.

Where You've Been Counts Too—A Look at Places

One of the wonderful benefits of taking pictures with your iPhone is that it records location information along with the other metadata. Photos for macOS takes advantage of this in a few ways, and it's worth understanding what's going on here.

Unlike Aperture and iPhoto that had a dedicated Places interface, Photos integrates this information into the Places Album, Memories, the search function, and the Info display. The iPhone records the location during capture, and then that place is displayed as part of the header information in Moments, Collections, and Years, and anywhere else in the app where location information is appropriate.

If you click on the name of the location in Moments, for example, you'll be transported to a Memory that

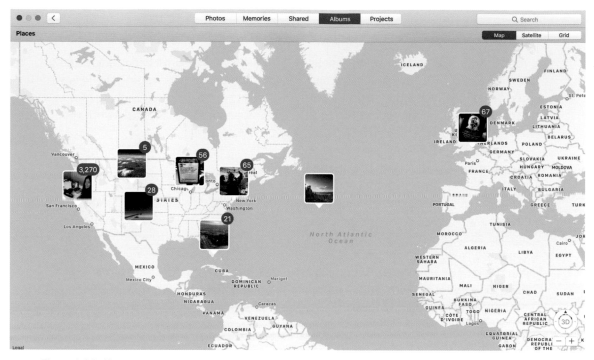

Figure 4-14: If your camera records geodata, Photos can show you where you've been. Here are some of the places I've photographed recently.

includes a map that plots the locations of the images in that group. Click the back button, and you're returned to Moments.

This works with Search also. I take a lot of pictures around my home, so if I enter "Santa Rosa" into the search field, I see a number of potential locations where I've snapped photos. With each result shown in the list, I'm provided with a thumbnail and the number of pictures included in that particular moment, memory, or place.

Even the Info box shows you a map with a pin indicating the very spot where you captured the picture. And if

need be, you can adjust the location in case it was recorded incorrectly. (See an upcoming section on GPS editing.)

The big change in Photos 2.0 was the creation of the Places album. You should see it there in the top row of the application albums with People and Favorites. Double-click on the Places album and a map takes over the screen showing the various locations of your geotagged images. Double-click on any of those thumbnails, and you're presented with the images in that group, from that particular location.

For a real treat, click on the Satellite button in the upper right corner to see

your thumbnails positioned on a globe. It's quite beautiful. And you can zoom in or out via pinching on a trackpad or using the plus and minus buttons in the lower right corner.

There is also a grid view that plots the thumbnails on a white background, but I find it wholly unsatisfying after using the map and satellite functions. Also, it's worth noting that other cameras, in addition to smartphones, are capable of recording geotags, and Photos can read that data as well. So you don't have to be shooting with an iPhone to take advantage of this feature.

What I like about the Places integration is that I might not remember when

I was in Hawaii, but I can quickly find that out by simply entering the location in the search box or by clicking over to the Places album. Ah, those were good times . . .

The Memories Tab

With version 2.0, Photos introduced Memories. This AI-driven functionality is incorporated into many areas of Photos, and it has its own tab at the top of the interface, right between Photos and Shared.

Memories is a whole new way of viewing your images. It relies on

Figure 4-15: The big moments of your life, at least according to Photos, is waiting for you in Memories

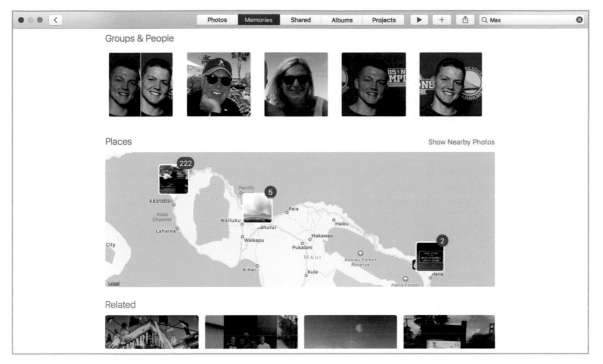

Figure 4-16: Also included, if available, are the people and places associated with that memory

bits of metadata such as geotagging, timestamps, and facial recognition to pull together groups of pictures that tell a story about a person, place, or time . . . or all three at once!

I think this will become a primary organizational direction of Photos. We may or may not ever see star ratings or color labels for tagging pictures in our library. My sense is that we will not. Instead, we will have these new tools that rely on the metadata that our cameras collect or that we add through tools such as Faces.

This approach makes sense for Apple. Why rehash a system that's already used in every other application, and has been leaned on for years? Instead, Apple has pioneered a new way to view our collections of images. And that direction seems to be Memories.

Click on the Memories tab and you'll be greeted by a column of bill-board-sized pictures with titles such as, Last Week, Home, On this Day, and Best of the Year. The content in your library helps determine the collections that are created by Memories.

Double-click on any of these Memories, and there are a variety of delights presented to you. At the top is a looping slideshow featuring images

from that particular collection. If you click on the play button up on the toolbar, you can enjoy a full-screen presentation, complete with music. These can be quite moving, depending on the memory itself.

Below that are individual photos from that Memory, followed by People, then a Places map plotting their locations. (Keep in mind that these various bits of data would need to be in your library for these sections to appear. If you don't have any geotagged pictures or have not identified any faces, the Memories won't be as detailed.)

Depending on the size of your library, and the amount of time Photos has had to process all of the information in it, you should have additional Memories listed at the bottom of the page under the Related header. Think of this like the "you may also be interested in" feature in online stores. You buy a clock radio, and you're offered deals on nightstands and pillows.

At the very bottom of the page are two links: Add to Favorite Memories and Delete Memory. If you add a Memory to Favorite Memories, then a new album is created under the Albums tab to keep track of them. And if Photos pulls together a Memory that you would just as soon not remember, you can delete it.

So, are Memories a worthy replacement of star ratings and other traditional organizing tools? That's a question that I've grappled with myself.

If you've been populating Faces and Places, then I think Memories can be very useful, especially as you build up a Favorite Memories collection. And the presentation of a Memory is magically wonderful at times.

But for experienced digital photographers, this approach requires an open mind and a willingness to experiment with the tools. I advocate giving Memories a try. I'm going to. And I'm curious as to what my opinion will be after a year's use.

A Tip for Organizing Your Library

If you're someone who misses the tightly structured left panel in Aperture, try this. Go into the Album tab in Photos, and then create albums, folders, and smart albums to catalog your images in a structured manner.

Top-level folders can include places, people, events, etc., to be filled with albums that fall into those categories. You can use Smart Albums to fine-tune your favorites by adding conditions such as location and time. Faces can also help you pull together portrait albums.

After you've done some of this foundation work, go to View > Show Sidebar. All your albums and folders will

be displayed neatly on the left side of the interface. You can adjust the size of the sidebar by clicking and dragging on its frame.

Step back and look at your structure. Do you need more folders? Would more Smart Albums be useful? Should some of your Smart Albums go in folders?

At the beginning of this chapter, I wrote about how Photos for macOS has flattened the structure for displaying our images. That's true. But I have also explained that we can augment the structure with our own organizational preferences. And as you can see, that's also true.

I'll leave it up to you to ponder this a bit more. The point I want to make is that there's more organizational power in Photos for macOS than might initially meet the eye. And by creatively applying the tools I've covered here, you can create a comfortable home for your picture collection.

738

STOCKTON ST.

Basic Editing Techniques

When it comes to editing your pictures in Photos for macOS, you can do a little or you can do a lot. This chapter is for those who don't want a lot of fuss and would like to stick to the basics of photo editing. These adjustments can be mastered in less than an hour. How's that for reasonable?

Now, if you want to get serious about your image editing, Photos for macOS can accommodate that too. I'll uncover more of those tools in the next chapter. But before we get to the serious wrenching, let's take a look at the basics. This is the easy stuff; the low hanging fruit that can make your snapshot shine.

The Basics Are Useful

I'm no auto mechanic, but I know enough to keep out of trouble. When the gas gauge nears empty, I fill it up. Once a month I check the oil level and add more as needed. I know that tires can lose pressure over time, so I check them periodically at the gas station. I'll even top off the wiper reservoir if I think of it.

Just doing these few basic things keeps me up and running. I feel like I'm doing my part. And the same can be said for managing your pictures.

You don't have to be Ansel Adams to make a good photo. A little cropping here, a bit of brightening there, and the next thing you know, you're showing off that great vacation shot to the entire family.

Easy Editing Adjustments

The editing tools in Photos for macOS appear very simple. The top-level adjustments only require a click or two. The Enhance tool is a perfect example. You click on it, and your picture looks better (at least most of the time). That's about as easy as unlocking the doors on your car.

Beyond that, there are additional levels of editing. Most of the time these tools require a click and a drag to get you where you want to be. In this chapter, I'm going to show you the top levels of adjustment tools. You may want to try this on your computer as you read along.

Find an image that you like in your Photos library, double-click to enlarge it, and then click on the Edit Photo button

Figure 5-1: Ready to edit? Pick an image, and click the Edit button in the upper-right corner.

in the upper right corner. It's the icon just to the left of the Details button. The interface should darken, and you'll see a column of icons down the right side. You're now in editing mode. And this is where we'll begin.

Top-Level Editing Tools

The simplest available tools require only a click or two to apply a change to the picture. We'll start with Enhance, Rotate, and Filters.

Enhance Is the Model of Simplicity—or So It Appears
The Enhance tool resides at the top of the column. Click on the magic wand

icon, and Photos makes an attempt to analyze and then improve the picture. Even though this is just one click for you, a number of things are happening beneath the hood. And if you want to see what those are, click on the Adjust icon (fifth from the top of the column), and then open Light and Color. And the sliders are labeled with terms we recognize, such as Light, Color, and B&W.

REVEALING THE ARROWS

Hovering your cursor at the top right of each correction tool will reveal a down arrow, which you click on to reveal their individual sliders.

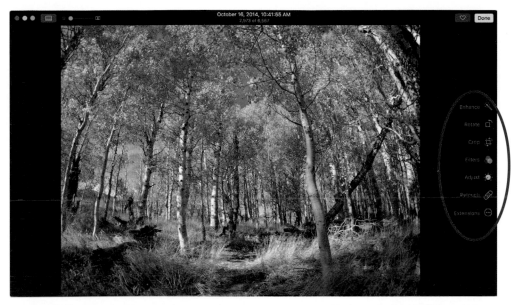

Figure 5-2: In editing mode, the application background switches to black, and a list of tools and icons appears in a column down the right side

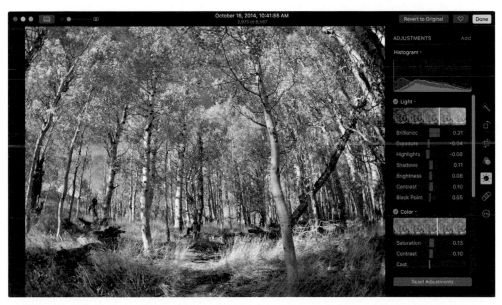

Figure 5-3: These changes were made by the application by simply clicking on the Enhance button

I've opened the sliders view here to show you what to look for. In the case of this example photo, you'll see that by simply clicking on the Enhance option, adjustments were made to Exposure, Highlights, Shadows, Brightness, Contrast, and Black Point (under Light), plus Saturation and Contrast (under Color). All of that happened just by clicking one magic wand icon!

I'll return to those sliders in the next chapter. But for now, go ahead and close them by clicking on the arrow that's pointing upward.

DID ENHANCE MAKE IT BETTER OR WORSE?

That's the question in image editing. A quick way to find out is to press the M key while in Edit mode. In this case, "M" stands for master. And Photos will show you how the image looked before clicking the Enhance button. This works for many of the other editing tools too.

Rotate *Puts Everything on the Up and Up*

Every now and then, a picture will come in sideways. This can happen with an iPhone or a regular digital camera. Click on Rotate, and your picture will do just that, 90 degrees per click. The default dirction is to the left. But if you hold down the option key while clicking, the direction will reverse to the right.

FEEL FREE TO EXPERIMENT

This is a good time to discuss nondestructive editing. Why? Because I want you to be fearless in your exploration of these image editing tools. As far as I know, you can't ruin a picture with these editing tools. You can always return to its original state with the Image > Revert to Original command.

That's because Photos for macOS is a nondestructive image editor. When you apply a filter, for example, the application "reads" your original image and then applies the changes to what's called a "preview." Every time you select an adjustment, the application updates the preview. In essence, you're always working on a copy. The original is safe and sound, untainted by your experimentation. So let your creativity soar!

Filters *for Instant Art*

Yes, I skipped over cropping, just for the moment, to discuss filters. If you use Instagram, then these should feel familiar. Click on the Filters icon, and a column of thumbnails appears. Each one is a different rendering of your image.

Click on different samples to see how they affect your photo. If you see one you like, you don't have to do anything else. Photos will remember your selection. If you change your mind,

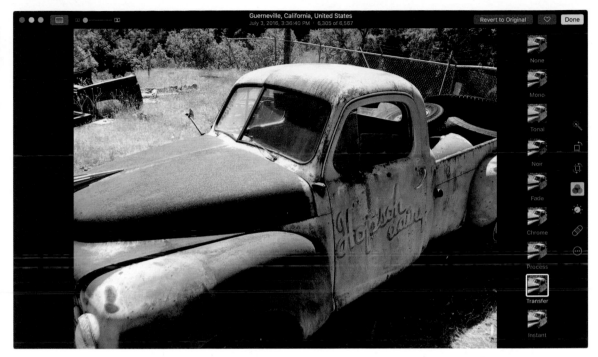

Figure 5-4: The Fade filter applied to a photo

chose None at the top of the thumbnail column, and your image will return to its previous state. To hide the Filters thumbnails, click on its icon at the far right.

These are our top-level editing tools: Enhance, Rotate, and Filters. I like to call them our "one-click wonders." But we have so much more to investigate. Let's dig a little deeper and see what we find.

Next-Level Editing Tools

This is the point where things start to get interesting. The next level of editing adjustments provides us with more control over the appearance of our photographs. We'll start with cropping and go from there.

Cropping *for Better Composition*

When we take a picture, there are a lot of things going through our head. Timing is important, of course. Plus there are all

Figure 5-5: We don't always have time to get the perfect composition

those camera settings. And we usually have to press the shutter quickly. As a result, we might not frame the picture as tightly as we should, or we might not even get it straight for that matter.

That's why cropping is so handy. It's like a second chance to frame your composition. Photos not only allows you to tighten things up, but you can even fix that slanted horizon line. (No one will ever be the wiser.)

Here's a perfect example using a shot captured with my iPhone. I stepped out of my garage one morning and noticed these three bandits peering out at me.

You don't see them? Well, I wouldn't expect you to because I had only a few seconds to pull the phone out of my pocket and snap this shot. Then they were gone. But I can improve matters considerably by clicking on the Edit Photo button and then clicking on the Crop tool.

By grabbing one of the handles on the frame that appear in each corner, or by pulling any of the sides inward, I can tighten the composition and direct the viewer's eye to the raccoons. Once you have the frame the size you want, you can click and drag the image inside the frame to reposition it.

Figure 5-6: After cropping the picture, the viewer can see what attracted you to the scene in the first place

If you need to straighten your image, click on the dial just to the right of your image, and drag up or down on it to rotate. Let go of the mouse button once it's fixed. Clicking on the Crop icon will lock in your changes. Doesn't that look a lot better?

TRACKPAD USERS REJOICE!

Yes, you can click and drag as previously described for straightening an image. But if you have a trackpad, use two fingers to rotate, and then spread and pinch to zoom in and out. It's way faster.

You can always change your mind because Photos is a nondestructive editor. Click on the Crop icon again, and the frame comes back, allowing you to change the dimensions of the crop or reposition the image inside the frame. You can start all over again by clicking on the Revert to Original button. And there's an Auto button (toward the lower right of your interface) if you want to let Photos make the cropping and straightening decision for you. But I rarely agree with it.

You can constrain your crop to a particular aspect ratio, such as 5 × 7, by clicking on the Aspect button and

choosing the dimensions you want from the popup menu. This option is particularly handy when making prints. That way, there will be no compositional surprises emerging from the printer. If you crop to 5 × 7 and print on 5 × 7 paper, what you see on the screen will emerge from the printer.

This is also where the Flip command resides. Be careful with this one, however. If there's type in the photograph, that too will be flipped, leading to an embarrassing edit.

Light and *Color*—Basic Adjustments to Improve the Picture

The Adjust button is found right below Filters. Clicking on Adjust will cause the Light and Color sliders to appear. The default view should look something like figure 5-7. You can adjust the lightness of an image by clicking on the vertical white line in the Light slider and dragging it to the left or right. Color works the same way.

These sliders seem simple, but they're actually pretty smart. Try an adjustment with Color. Then, click on

Figure 5-7: Click on the vertical white line in either Light or Color to adjust the image

Figure 5-8: Open the Color panel, and you can see the detail of the adjustment you made

the downward arrow that appears when you mouse over the Color slider. That will open another panel with more sliders. And you'll see that Photos has tapped all of those settings when you were making that one adjustment at the top level.

Once you've had a peek, go ahead and close it. We're going to learn how to use all of those sliders in the next chapter. Before we leave them, however, take a look at the blue circle with the checkmark in it. You can temporarily turn off that adjustment by unchecking it. This might not sound like a big deal now, but later, when you have lots of adjustments applied, it's very helpful.

Figure 5-9: You can reset a single adjustment using this popup menu

And there's a small downward arrow to the right of the word Light. Click on it to reveal a small popup that lists Reset and Remove Adjustment. Reset lets you start over again with just that particular tool. Nice. That's much better than using the Revert to Original command and having to begin from scratch.

Remove Adjustment will make Light disappear from the active Adjustments panel. Don't worry if you accidentally click on Remove Adjustment. You can

bring Light back by clicking on the blue Add label at the top of the panel.

Black & White Conversion Too

Before we leave the Adjustments panel, there's one more easy slider for us to play with: Black & White. Click on the blue circle to activate it, and then click on the white line and move it to the left and right. You'll see a variety of monochrome effects applied to your image. You can turn off Black & White by unchecking the blue circle.

Figure 5-10: Images can be converted to Black & White in the Adjustments panel

Retouch—Yes, I Can Remove That Blemish

This is the last of our basic editing tools, and it's a good one. The Retouch tool allows us to remove spots and blemishes. Appropriately enough, it's represented by a Band-Aid icon in the Adjustments panel. Click on it, and you'll see a simple vertical line with a solid circle on it.

Click on the circle and drag it upward or down. An empty circle will appear indicating the size of your healing brush. Generally speaking, you only need a diameter that's a bit bigger than the blemish you want to remove.

Once you have the size you want, click on a blemish and watch it disappear. This is beautiful magic. The application is really good at choosing a source area that creates a seamless match for the area you're fixing. If you don't like what Photos is choosing for the source, you can influence it by Option-clicking on an area of the image to select it as the source, releasing the Option key, and then clicking on the blemish to remove it.

My advice is to keep your fixes relatively small in size. A giant healing circle can produce some unflattering results. So remain patient and keep those fixes discrete. And say good-bye to annoying pimples.

This Concludes Round One

So that's it for the basics. Not too bad, right? And hats off to the Photos design team for making these powerful adjustments so accessible. But if you're like me, you're already craving more editing power. Good. Because we're going to explore the sophisticated adjustments in the next chapter. And I'll tell you right now: it's fun.

Advanced Editing Techniques

Advanced editing isn't something you do for every picture. The extra time you spend adjusting tones and colors should be reserved for your favorites. But when you do capture a magical moment through the lens of your camera, these tools and techniques will help you polish that image so you can share with the world.

Making It Better

When I was a kid, I loved working on things. My favorite victims back then were bicycles. I would turn mine upside down and use the handlebars and seat as a stand, exposing its underside to my critical eye. I inspected every gear and moving part until I could find something to adjust.

"Those pedals feel a little sticky. I can fix them," I thought.

Father's toolbox was my accomplice. First, I'd remove the pedals. Then I'd thoroughly clean every part and re-grease them. The final step was to put the entire assembly back together. I was successful more than half the time.

I wasn't taking things apart just for the sake of exploration. I wanted to make the bike run better. My theory was, by cleaning out the dirt and grime, I could pedal faster and reach my destination in less time. That's the thinking of an 11-year-old boy.

One day, my Dad became frustrated with me because I wasn't nearly as good at putting his tools back as I was at borrowing them. He locked up the wrenches and screwdrivers.

"Just leave well enough alone," he said. "Your bike runs fine."

"It could ride better," I thought.

I think photo editing is a bit like this. For the most part, our pictures are pretty good as is. Some would say they look just fine. Yet, I want to make them better.

That's what this chapter is about—making your pictures better. These techniques are what separate a photographer from a snap-shooter. We're not satisfied with the casual click of the shutter. We want to crop, lighten, add warmth, and make those details pop.

As a boy, I would dream of riding faster than every other kid in my class. My finely tuned bike provided the edge I needed. And when my Dad would forget to lock up his tools, I'd resume my mechanical quest to pursue that goal.

Figure 6-1: An iPhone scenic fine-tuned with the advanced editing tools in Photos for macOS

These days, I focus more on photographs (although I still fix my own flats). I want our pictures to look better than everyone else's. Part of that is good capture. But the other part is editing. Photos for macOS has the tools we need to perfect our images. And that's exactly what we're going to work on in this chapter.

and correct color. Along the way, I'll also explain how you can customize the Adjustments panel to suit your own tastes.

Speaking of the Adjustments panel, that's where we're going to be working for this entire chapter. There's a lot to explore. Let's get to work.

Picking Up Where We Left Off

In chapter 5, we started with top-level tools. Cropping and retouching are edits that I apply to nearly every image. But now, instead of stopping there, we're going to press forward and learn how to open up shadows, recover highlights,

Working with the Add Menu

The Add menu contains a variety of editing options that we don't initially see when we open the Adjustments panel. Why wouldn't Apple just show us all of these at once? It's a good question. But my feeling is that Photos

was designed like an onion. If you want more layers of capability, you'll learn how to peel it. And if you don't, you won't be intimated when you first open the Edit tab. But we both know why you're here. You want to peel that onion.

Click on the Add button, and you will see a list of every tool that's available in the Adjustments panel. So this is our roadmap. The Add menu is divided into three sections: Basic, Details, and Advanced.

Figure 6-2: The Add menu in the Adjustments panel

The labels that have checkmarks next to them are active in the Adjustments panel. Those that don't have checkmarks can be activated by clicking on their name. When you activate a tool, it is positioned in the same order on the Adjustments panel as it is listed in the Add menu. So, for example, if you add Noise Reduction, it will be positioned beneath Definition.

At the bottom of the Add menu is Save as Default. By clicking on this, the application will remember the active tools and will list them for you in the Adjustments panel every time you access that area. We all have our favorite tools. Save as Default keeps them at our fingertips. I'll talk more about that at the end of the chapter.

If you go to any of the tools and you don't see the sliders that I'm showing in an illustration, it's just that the tool needs to be "opened." Click on the down arrow that's next to the Auto button. That will reveal those sliders that you're looking for.

> **REMEMBER TO HOVER!**
>
> Some options won't appear unless you hover your mouse pointer over the area. To open the various sliders, hover your pointer over Light, Color, Black & White, Noise Reduction, or Vignette, and the Auto button, and then the down arrow to open the sliders will appear.

Basic Tools in the Add Menu

We're going to revisit three old friends: Light, Color, and Black & White, plus we'll make the acquaintance of a new one: Histogram. Previously, I restrained from delving beyond the basics of using these tools. All bets are off now.

Understanding the Histogram

I'm starting with the histogram because, well, for one thing, it's at the top of the Add menu. Additionally, it helps us understand, at least graphically, what's going on when we move the various sliders. There are four basic components here. The red, green, and blue lines represent the three color channels of RGB. The grayish part of the graph represents luminance, or brightness. At this point I wouldn't get caught up in the four different components, but just look at the histogram as a whole. Think of it as parts to a single creature.

Figure 6-3: The Histogram

The lines and shapes on the right side of the graph represent bright tones. On the left side the dark tones are graphed. And as you've probably figured out by now, the central area displays the middle tones in an image. When you move any of the sliders in the upcoming Light panel, the histogram will change shape to graphically represent the adjusted image.

Generally speaking, for most outdoor photos, a distribution across the entire tonal range often means a relatively good exposure. We'll revisit the histogram in more detail when we explore Levels.

Working with the Light Sliders

You could argue that these are the most important sliders in Adjustments. After all, photography is light. And Apple has provided us with some excellent tools here.

Brilliance – Apple added this slider to the Light panel with Version 2.0 of Photos that shipped with macOS Sierra. They must have really liked how it turned out, because it's positioned at the top of the stack above Exposure, Highlights, Shadows, and the rest of the gang.

After testing it, I can understand their enthusiasm. Brilliance affects shadow, highlight, and mid tones all at once. So instead of having to play with multiple adjustments, Brilliance might be able to handle the job all by itself.

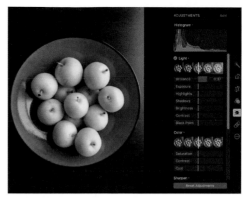

Figure 6-4: New Brilliance slider at the top of the Light panel. Image shown before adjustment.

Figure 6-5: Move the marker to the right in the Brilliance slider, and the shadows open up and some detail is recovered

Click and drag the blue marker to the right, and the shadows are opened up while highlights and mid tones show more detail. Colors also seem to brighten a bit. Move the marker to the left and the entire mood of the image changes again, with more intense dark areas and more graduated mid-to-bright areas (figures 6-4, 6-5, and 6-6).

Once you've handled your initial lighting adjustment with Brilliance, you can continue to fine tune the image with the subsequent sliders. So it seems quite logical that this newcomer resides at the top.

In a word, this new slider is, well, brilliant!

Exposure – Adjusts the brightest areas of an image. When you move the exposure marker to the right, the image will brighten, and the histogram will shift to the right. If the histogram begins to climb up against the right side of the graph, then you are losing detail in the highlights and most likely overexposing the image too. In this case, move the

exposure marker to the left to back off the brightness. It's OK if the histogram shape is touching the right side, just not climbing up it . . . well, most of the time.

There are always exceptions to these kinds of things. If you have an image with pure white in it, then those tones will appear on the histogram as climbing up the right side. And in that case, they should be. The point here is don't get married to any particular rules. Look at the photo, observe the histogram, and learn how they work together.

REMEMBER: THIS IS ALL NONDESTRUCTIVE

This is not the time to be timid. Make big movements with these sliders, and see where the edges are. Then you can back off and fine-tune. All of these edits are nondestructive. That means you can't ruin your picture. There's a big Reset Adjustments button at the bottom of the Adjustments pane. If you mess up the shot, click on Reset, and start over.

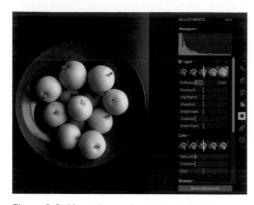

Figure 6-6: Move the marker to the left in the Brilliance slider, and the shadows deepen and the bright areas become more graduated

Highlights – Works in tandem with exposure to recover detail in the brightest areas of the photo. Even when your exposure is set correctly, some of the bright areas of the image may look a little washed out. The highlights slider helps you recover some of that tonal detail.

I love this slider because it allows me to have an overall bright picture, but with lots of visual information. Highlight recovery is most effective with RAW files because of the depth of data available. But it works well with many JPEGs too.

Shadows – Works in tandem with black point to recover detail in the darkest area of the photo. If you've ever heard the phrase "crush the blacks," it means there isn't any detail in the dark areas of the picture. Generally speaking, a little information there makes the image look more photographic. And that's what the Shadows slider helps you with.

(Sometimes you want to crush those blacks. This is a judgment call for the photographer.)

As you move the marker to the right, the darkest areas become lighter, revealing more information. You'll also see activity on the left side of the histogram. Some photos look better with a dash of pure black in certain spots, so if the graph is crawling up the left side of the histogram, but the photo looks good, don't worry about it.

Shadows is handy for opening up those areas where we feel there isn't quite enough light. But that doesn't mean we can't have a little pure black if we want. Think of it as a postproduction fill flash. Boy, I could have used this in the film days!

Brightness – Primarily affects the middle area of the histogram; it has the strongest effect on the midtones. Many photographers will adjust exposure and black point first and then will fine-tune with brightness. That's a pretty good way to go, actually.

Contrast – Changes both ends of the histogram at once. When you move the Contrast marker to the right, you increase the black point on the left side of the histogram and the exposure on the right at the same time. Moving the marker to the left decreases black point and exposure.

Black Point – Sets the point at which the darkest parts of the image become completely black without any

detail. This adjustment focuses on the left side of the histogram, affecting the dark areas of the image. Black Point and Shadows work together in a similar fashion to Exposure and Highlights. Once you set the overall black point of an image, you can recover some detail with the Shadows slider.

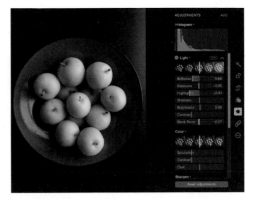

Figure 6-7: Here's the image after multiple Light adjustments have been applied

QUICK RESET

When you're playing with an image and you just want to start over in a particular panel, such as Light, you can reset the sliders by double-clicking on the thumbnail slider in the panel.

So, what's the best way to work here? I recommend that you start with Exposure and Black Point. Get the overall look of the brights and darks the way you want. Then use Highlights

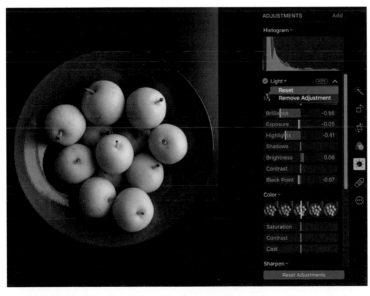

Figure 6-8: And if you want to start all over in the Light panel, just click on Reset

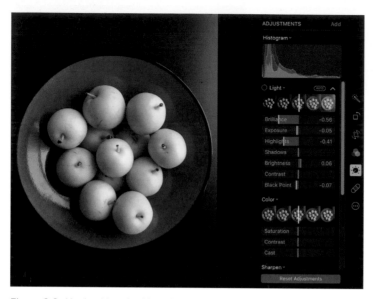

Figure 6-9: Unchecking the blue circle turns the adjustments off

and Shadows to fine-tune those adjustments. Finish off with Brightness.

You can check your work by pressing the M key to see the original image. Unchecking the blue circle next to the word Light will also disable the adjustments you made, and checking it again brings them back. There's a little dropdown menu to the right of the Light label (see the tiny down arrow?), which offers the option to reset all the Light sliders at once. And there's a big Reset Adjustments button at the bottom of the panel too, which will undo all the adjustments you've made to the image.

USING RAW AS ORIGINAL

If you shoot RAW+JPEG with your camera, Photos will accept both images, but it will bring the JPEG forward. You can see this via the J badge in the lower-left corner of the picture. To switch to the RAW image, click on the Edit button, and then select Image > Use Raw as Original. You're now working with all that RAW data, which is particularly good for highlight and shadow recovery. And when you exit Edit mode, you see that the J badge has been replace with an R badge. I talk more about this at the end of the chapter. But I thought you RAW shooters might want a heads-up now.

Figure 6-10: How can the Color controls help improve this image?

Working with Color Adjustments

In addition to luminance, color (or lack of it) is the other core area of image editing. I'm going to cover the Color panel next, but we don't get to white balance until the Advanced Adjustments, which seems odd to me. I think white balance is one of the most important corrections. But we're going to stick with the plan here.

I'm mentioning this so you have the right frame of reference as you walk through the Color panel. It's useful, for sure. But it's only part of the color picture.

Making color adjustments is even more subjective than luminance. To some degree, we have the histogram to help us make exposure decisions. Color is driven more by our perception.

When you look at figure 6-10, what's your evaluation color-wise? What I see is potential. It was a little overcast, so the color temperature is bluer than I prefer. Also, those trees clearly have potential, but their hues are too muted in the original. So let's see what we can do to improve the situation using the three sliders in the Color panel.

I like to start at the bottom with Cast and then work my way up to Saturation. Why? My thinking is, why would I want to increase the saturation of a picture with a bad color cast? That seems like making a bad situation worse. So I'm starting with Cast to fix things, and then we'll enhance a correct color.

NEED MORE COLOR ENHANCEMENT?

The default range of the slider scales for Saturation, Contrast, and Cast is –1.0 to +1.0. If you need a bit more contrast, for example, hold down the Option key and the scales extend to +2.0, allowing for even more intensity.

This Option key trick works for some other adjustments too (but definitely not all). So it's always worth a try if you run out of road while using a particular slider.

Cast – Provides a warm/cool correction. Move the marker to the left to cool the hues and to the right to warm them. For this image, I'm going to move the marker to the right a smidge to offset the cool-colored light of the overcast morning.

Contrast – Creates separation among similar colors in a picture. Move the marker to the left, and the colors become muted; move to the right to increase separation. I really like this slider, and for this shot I'm moving the marker over to the right to add a little punch to the image.

Saturation – Adds or decreases the intensity of color. Now that I have the cast and contrast to my liking, I'm going

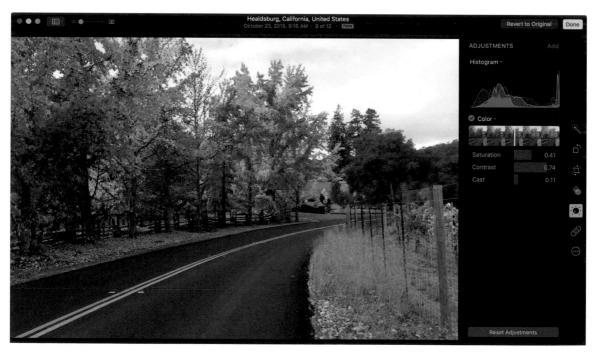

Figure 6-11: The result of my color corrections

to increase the saturation to finish up this particular adjustment.

For many photographs, you can stop right here. Luminance and color, along with a bit of cropping, are all we typically need to spruce up a picture. But Photos has much more—so we'll continue with a look at its excellent Black & White converter.

Converting to Black & White

I was pleasantly surprised to see that this well-executed Black & White converter was included in the Adjustments panel. You can create some really nice monochrome images here.

Before I cover the four sliders in this panel, I have a tip for you. For images that you want to convert to monochrome, work on them first in the Light panel. Luminance and Black & White work really well together. And you see in figure 6-12 that I have both of those panels open.

I usually start in Light, and then work in Black & White. I'll go back and forth between the two until I have the image the way I want. Let's see what Apple has dished up for us with this set of sliders.

Intensity – If you think about how saturation works for color, that's what

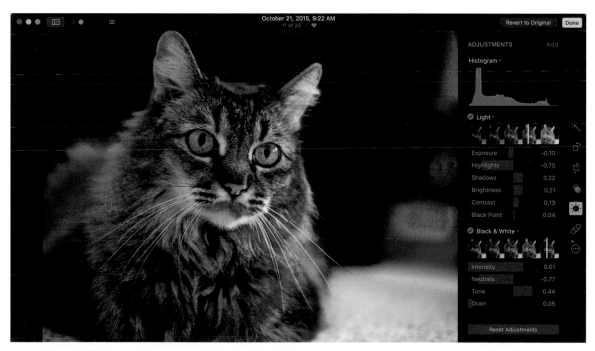

Figure 6-12: A color image converted to black and white

the intensity slider does for black and white. As you move the marker to the right, Photos intensifies the tones in the image. If one cube of sugar makes your coffee sweet, two cubes makes it even sweeter. That's what intensity does.

Neutrals – This slider affects the gray areas of the image by lightening or darkening them. For this image, I thought that darkening the gray areas helped create a nice separation from the white markings of the cat, including her whiskers.

Tone – This adjustment could really be called contrast, because that's what it does. Moving the marker to the right increases contrast, and to the left flattens it.

Grain – To complete the filmlike black-and-white effect, we can also add grain. Not only does this provide an analog feel to the image, it can make it appear a bit more crunchy.

IT'S STILL COLOR UNDER THE SKIN

Even though we're applying monochrome effects to our picture, it's still color inside. For example, you can still tweak the tones in your black-and-white image by using the temperature and tint sliders in the White Balance panel. Try it. Photos provides an amazing amount of control for your black-and-white pictures.

The Detail Sliders

The four Detail adjustments—Sharpen, Definition, Noise Reduction, and

Vignette—help you control the appearance of your image in different ways than luminance and color. I consider these the finishing touches to my image editing.

Generally, I spend more time with the Detail sliders for architecture and landscape subjects. Enhancing detail and texture isn't something most of your portrait subjects are looking for, that is, unless you're photographing craggy old fishermen. If the Definition slider allowed you to decrease detail, as Adobe Lightroom allows, then you could use that in portraiture to smooth out skin tone. But that's not the case in Photos because Definition is only additive.

So, in that spirit, we'll work on a landscape image that's the perfect

Figure 6-13: The Detail tools

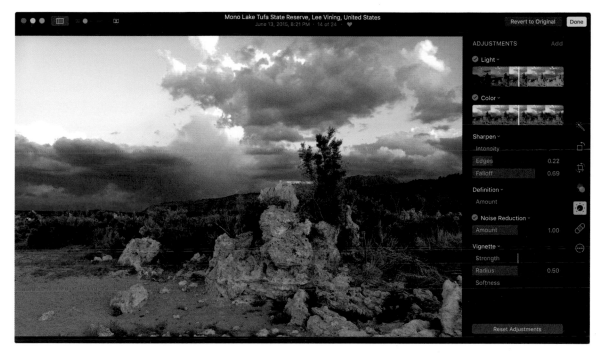

ADJUSTMENTS Add

Light ˅

Color ˅

Sharpen ˅
Intensity
Edges 0.22
Falloff 0.69

Definition ˅
Amount

Noise Reduction ˅
Amount 1.00

Vignette ˅
Strength
Radius 0.50
Softness

Reset Adjustments

Figure 6-14: Here's an image that's a good candidate for the Detail tools

candidate for enhancing detail, and we'll save portrait work for later in the book using other more suitable tools.

Sharpen

If you don't open the Sharpen panel via its downward arrow, you'll only have the Intensity slider to work with, plus the Auto button. For the most part, Intensity is all you really need, but let's go ahead and reveal the other controls, to at least understand what we're doing here.

Intensity – Moving the marker to the right increases the strength of sharpened edges. This slider has the most noticeable effect on your picture.

And some argue this is the only slider you need to use for sharpening. That's why it is the featured slider when the others are hidden.

Edges – Apple says that Edges sets the threshold for which groups of pixels are edges and which ones aren't. What that means is that we have some say in what the software determines to be an edge. The more you move the marker to the right, the greater the number of elements in the photo will be sharpened. I recommend that you keep this setting low. Moving the marker too far to the right can increase noise in areas such as skin and sky.

Falloff – Let me start by saying that you can leave this slider right where it is, and your life will be fine (that is, unless you know you need to move it). The Sharpen adjustment actually works its magic in three passes, although you won't notice it happening. (It's really fast!) The Falloff measurement is telling you how much it will sharpen on the first pass, leaving the balance for the subsequent two passes. Like I said, the default setting works just great.

For our landscape image, I left Falloff alone, kept Edges relatively low at 0.22, and increased the Intensity to 0.60. My thinking was that I definitely wanted to sharpen up those wonderful textures of the tufa (increase Intensity), but I did not want to introduce noise in the colorful sky (keep Edges low).

As a test, I clicked on the Auto button to see how Photos would analyze and sharpen this image. I found the results interesting. The application left Edges at 0.22 and Falloff at 0.69. But it was more aggressive with Intensity,

moving the marker to 0.81, opposed to my 0.60 that I had set.

I'm guessing that the application was keying off the textured tufa formation. Not a bad way to go. I decided to split the difference and moved the Intensity to 0.70. (You can do this by entering the number in the field by hovering and double-clicking.)

This is the nature of sharpening. We're walking the line between breathing as much life into our pictures as possible and trying not to go too far and create an unnatural, over-digitized photograph. When in doubt, be conservative (at least with your sharpening).

ZOOM IN FOR A CLOSER LOOK

By pressing the **Z** key, the application will zoom the area where the mouse pointer is positioned to 100 percent. You may find this view helpful when setting the Intensity slider, both to check the details of the tufa, and to watch for introducing noise in the sky (as in figure 6.14). Press the **Z** key again to zoom back out.

Figure 6-15: Here are the final settings I used for sharpening the tufa landscape photo

Definition

This is a single-slider adjustment that increases midtone contrast. It's akin to the clarity slider in Adobe Lightroom. Increasing definition is helpful for many compositions, with the notable exception being portraits. By increasing midtone contrast, details seem to come

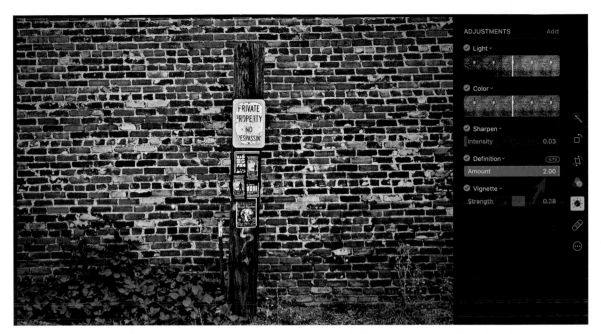

Figure 6-16: Holding down the Option key to further crank up definition can produce an almost graphical look to your photograph

to life. As with sharpening, don't overdo it, however.

Once again, I wanted to see what the Auto button does. I clicked on Auto, and it added 0.25 of definition. In this case, I had added 0.40. So this time I was more aggressive than Photos. As a result, I decided to back off a bit and go with the 0.25.

Do I always readjust after testing with the Auto button? No, I don't. But I am a fan of reality checks. And for the most part, Auto does provide that. So I weigh what the application "thinks" against my own judgment, and I take things from there.

If you want to really bump up definition beyond 1.00, then hold down the Option key to allow for adjustments up to 2.00. Be careful what you ask for, however; going this far can create an edgy, almost graphical look.

Noise Reduction

The good news is that the Noise Reduction tool has the ability to clean up the speckles and grain-like artifacts that can infiltrate the sky and dark areas of a photo. The bad news is that everything in the photo gets a little blurry. If your composition is all sky, go ahead and crank up the noise reduction. But if you have textures you want to preserve, such as in our landscape composition, then you might want to be conservative with this slider.

Interestingly enough, if you hold down the Option key while moving the marker to the right, you can exceed the normal maximum of 2.0 and crank noise reduction all the way up to 5.0. Whoa! Try that on a portrait, and see what you think. You suddenly have a watercolor. Hmmm . . . keep that in your back pocket. You never know, right?

For our landscape image, I'm going to bypass noise reduction altogether. I don't want to sacrifice any of the foreground detail for a bit of additional smoothness in the sky.

NOISE REDUCTION FOR SKIN SMOOTHING?

There isn't a built-in skin-smoothing tool in Photos, but in a pinch, you can try noise reduction. Try a setting between 2.0 and 4.0 (holding down the Option key), and see what you think. Again, it's all about tradeoffs. The skin will definitely get smoother, but you have to balance that against the other details that get blurred too.

Vignette

The Vignette tool can be used to lighten or darken the edges of an image. There are three sub-sliders to help you customize the effect.

Strength – You can darken or lighten the effect by moving the marker to the right (darken) or to the left (lighten). Lightening the edges is often referred to as devignetting, because it can offset an unintentional vignette caused by a lens hood that's too small.

Radius – The size of the effect is controlled by the Radius slider. To clearly see this, move the Strength slider all the way to the right for maximum effect, adjust Radius to taste, and then finish by backing off the strength until the image has the desired appearance.

Softness – For more of a feathered look to your vignette, move the Softness slider to the right.

The best vignettes are those that the viewer doesn't notice. You can subtly direct attention to the central portion of the composition without shouting, "Hey, this picture has a vignette!" Interestingly enough, there is an Auto button here. I think that's a bit odd, considering that this seems more like an artistic call rather than fixing something such as an unappealing color cast. And it's a terrible Auto button, to boot. Every time I use it, my picture looks like one of those old-time portraits you see in an antique shop. No reality check needed here. Just pretend that Auto isn't there.

The Advanced Sliders

Both White Balance and Levels fall into this final category in the Adjustments Add menu. I love both of these tools

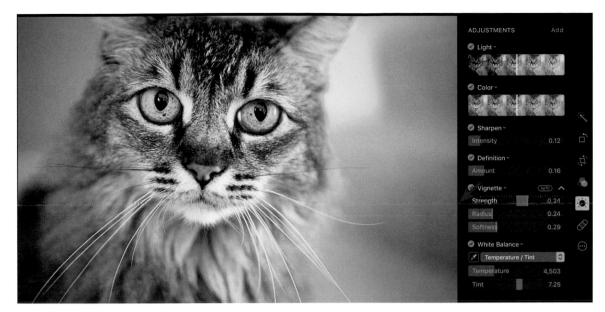

Figure 6-17: Well, now that you've pointed it out, yes, I can see the subtle vignette in this portrait. But would you have noticed if I hadn't said anything?

because of the control they give you over luminance (levels) and color (white balance). Photographers used to working in Photoshop, Lightroom, and Aperture will most likely want to add both of these to their default set.

White Balance

There are three setting types in this adjustment panel: Neutral Gray, Skin Tone, and Temperature/Tint. Click on the Auto button, and Photos will select the type that's most appropriate for the image and will make a suggested correction. You can fine-tune this suggestion via the available sliders. Let's take a closer look at the three types and the sliders they offer.

Neutral Gray – This adjustment keys off the neutral tones in the image to correct the entire picture. Its warm/cool slider allows for user customization. Neutral Gray is simple to use and works great for images that contain neutral tones for it to sample.

Skin Tone – If a person dominates the composition, then Photos will choose Skin Tone and make its color correction for the entire image based on the person in it. As with Neutral Gray, you have a slider in Skin Tone that provides for warming up or cooling off the color.

Temperature/Tint – This is my personal favorite because it provides two sliders for customization: Temperature for warm/cool adjustments and Tint for magenta/green hues. Just like with the

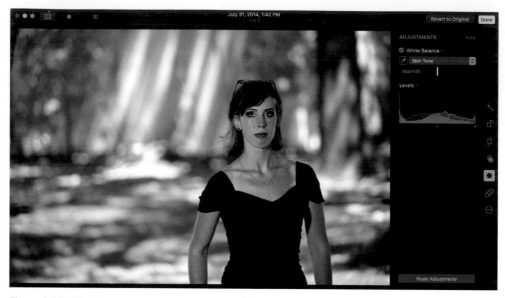

Figure 6-18: Clicking on the Auto button in White Balance prompted Photos to pick the Skin Tone type and make a correction

other two types, the Auto button does a good job of getting you close. With the sliders, you add the finishing touch.

Manually Choosing the Type – Even though the Auto button selects the white balance type based on Photos' analysis of the picture, you can choose whatever you wish from the popup menu. In my case, I prefer Temp/Tint over Neutral Gray, so I use this option often.

Eyedropper Tool – Once you choose a type, you can take even more control with the eyedropper tool. Click on its icon, and then sample the appropriate area. For Skin Tone, click on a clean area in the face. For Neutral Gray and Temp/Tint, try to find a gray area and click on it. I sometimes include a Black/White/Gray card in the first photo of a series specifically for this reason.

USE TEMPERATURE/TINT FOR EXTREME CORRECTIONS

Another advantage with Temperature/Tint, beyond having two sliders instead of one, is that you can hold down the Option key to enable even more warmth and magenta if necessary. You don't have this ability with Neutral Gray or Skin Tone.

As I mentioned earlier, I think color is important. The white balance tool not only helps us correct hues misread by our camera, but the sliders can be applied artistically too. For example, if you're shooting a portrait using existing light inside next to a window, you may want to further enhance the bluish tones to create a more somber

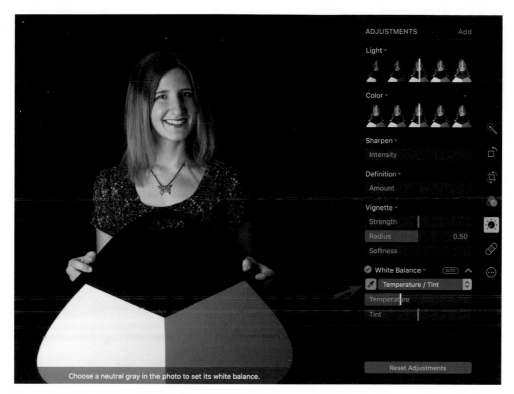

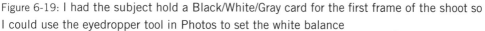
Choose a neutral gray in the photo to set its white balance.

Figure 6-19: I had the subject hold a Black/White/Gray card for the first frame of the shoot so I could use the eyedropper tool in Photos to set the white balance

mood. On the other hand, adding a little extra warmth can serve as an antique filter or convey comfort and coziness.

So, even though White Balance is primarily a correction tool, don't limit its power. You have a powerful creative adjustment that can help you convey the emotion you want a particular image to exude.

Levels

The advantage of working with the Levels adjustment is that you have a histogram to serve as a visual aid, and you have several micro adjustments. This provides a level of control (yes, I did the pun on purpose) that you don't get with Light.

In the beginning, try the setup I have illustrated in figure 6-20. To create this, go to the Add menu and turn off everything except for Histogram and Levels. The Histogram on the top will show you the changes that you make with the Levels adjustment below it. This is a really good way to get comfortable with Levels.

Figure 6-20: To help you get familiar with how Levels works, try this setup

When you start out, both graphs will look identical, as in figure 6-20. Now let's see what happens as we make changes. I want to increase the contrast a bit, so I'm going to start with the two markers on the bottom of the Levels display that are positioned on the ends. The left end impacts the dark tones, and the right end will adjust the bright areas. I'm going to move them both toward the middle a bit, thereby increasing the contrast of the photo.

As I do this, the top histogram changes to reflect my edits. The bottom histogram does not. How cool is that?

Now I'm going to move the middle marker on the bottom to the right to darken the image. This affects middle

tones. Again, the top histogram will move to reflect my changes.

Finally, I'll work with the smaller markers on the top and bottom to make smaller adjustments. (This is totally optional. In fact, I rarely use them. But I thought you might be wondering what they do.) If you want to move the top and bottom pair as a set, hold down the Option key. For independent adjustments, don't use Option. Here's how the edited image looks (figure 6-21). See how the top histogram has changed to reflect our adjustments.

Check your work by clicking the blue circle next to the Levels label. That will turn off and on your adjustments. If you'd prefer a more simple histogram

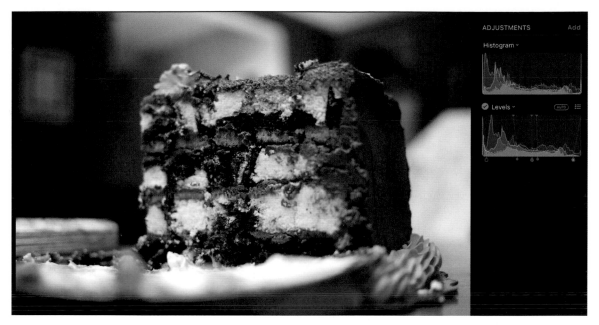

Figure 6-21: Here's the adjusted image

in Levels, go to the small menu icon and select Luminance. (It's next to the Auto button.) The problem with this is you can't do this for the top histogram.

While you're in this menu, notice that you can look at the individual red, green, and blue channels too. The Auto button next to the menu is a good starting point if you're not exactly sure what you want to do.

And finally, it's OK to use Levels in conjunction with the Light controls, as shown in figure 6-22. They affect the image differently, and with all of these sliders, you should be able to get the perfect exposure for your photograph.

OK, full disclosure here: when you get to the end of the chapter and see what I've included in my default set of adjustments, Levels won't be there. "But why? You just said they are so cool." Well, yes, they are. But for me personally, they are also old school.

I used levels back in the early days of Photoshop before we had the advanced algorithms we enjoy today in the Light panel. Even though those labels of Highlights and Shadows seem simple, there's a lot of sophisticated code behind them. And to be honest, I like that help.

If you love the Levels adjustment and have always loved levels, then by all means keep using them. But my point is, if you don't want to, you don't have to. (I'll never force you to

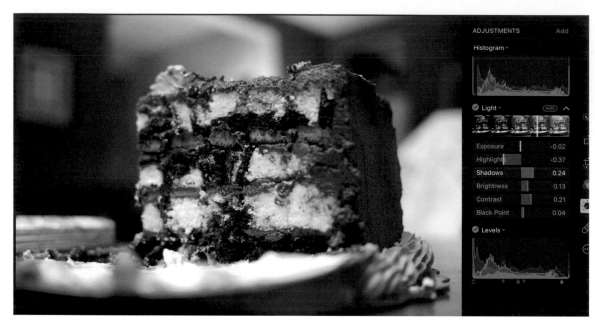

Figure 6-22: You can use Levels with the sliders in the Light panel

eat broccoli either.) The Light panel is amazing. And in most situations, I think it can accommodate your luminance needs just fine.

Tips to Improve Quality and Efficiency

Learning how to use the various sliders in the Adjustments panel provides you with a lot of firepower to polish your photographs. What I want to do next is to help improve your quality and efficiency when working with these powerful tools. I'll start by showing you how to copy and paste a set of adjustments. Then we'll wrap up with a discussion

about RAW files and organizing your workspace.

Copy and Paste Adjustments

Once you perfect one image in a series, such as a sequence of portraits shots, you can apply those settings to subsequent frames by using copy and paste adjustments. For this type of work, I recommend turning on Split View (View > Show Split View) so you can quickly move from one image to the next.

The process is simple. First, edit an image in the sequence. Then, while still in Edit mode, copy the adjustments

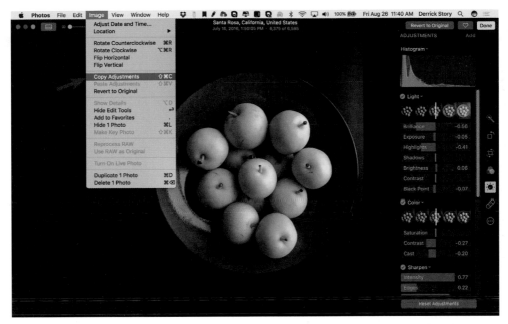

Figure 6-23: I've applied a number of adjustments to this photo, but I can copy them and apply to others too

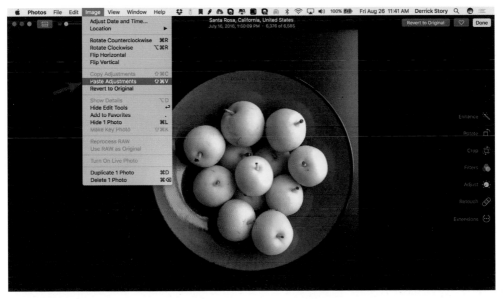

Figure 6-24: All the edits from the previous picture will be applied to this one

(Image > Copy Adjustments). With Split View on, you don't have to leave Edit mode to go to the next image. Click on its thumbnail and then Paste Adjustments (Image > Paste Adjustments) to the next photo.

Check your work by pressing the **M** key to see the original. At this point, you can either stick with the existing edits, adjust them further, or revert to original (Image > Revert to Original).

KEYBOARD SHORTCUTS

Certain tasks, such as copying and pasting adjustments, can be even more efficient by using keyboard shortcuts. They are listed next to the menu item (such as Shift-Command-V for Paste Adjustments), or you can view an entire list by going to Help > Keyboard Shortcuts.

Working with RAW Files

Many photographers, myself included, capture in RAW+JPEG. There are many situations where this makes sense, the most common being that the JPEG is immediately shared from a WiFi camera to a mobile device for posting online, while the RAW is saved for postproduction on a computer.

Photos for macOS copies both versions to its library. But it places the JPEG on top. You can see this by the J badge in the lower-left corner of the picture in browsing mode and by the denotation JPG at the top of the picture in Edit mode.

Because the application can handle RAW files perfectly fine, most photographers prefer to use those versions for editing. You can instruct Photos to do just that by first going to Edit mode and then going to Image > Use RAW as Original. The RAW file will be placed on top and made available for adjustments. The JPEG is still there behind the RAW. And in fact you can switch back by returning to the Image menu and selecting Use JPEG as Original.

RAW files are particularly good for using the highlights and shadows sliders in the Light panel. And overall, you have more data to work with during the editing process. When you're recovering detail in an image, there's just more water in the well with RAW files.

If your camera is brand-new, Photos may not support its RAW files right away. Apple releases updates to its RAW support on a regular basis. This is another case where shooting RAW+JPEG is a good idea. You can work with the JPEGs until the RAW support is added for your camera. Then switch to RAWs as desired.

Figure 6-25: You can bring the RAW file forward for editing

Setting Your Default Adjustments Panel

Apple provides us with a non-intimidating starting place in the Adjustments panel. The default list includes the basics: Light, Color, and Black & White. But after experimenting with all the other sliders available, you, like me, will prefer some

to others. So it's time to make your own default Adjustments panel.

Go to the Add popup menu. Check the items you want by clicking on them, and uncheck the others. When you have everything the way you want, click on Save as Default at the bottom of the popup. This will be your starting point for image editing.

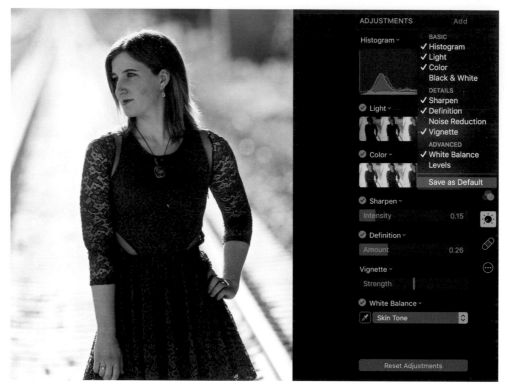

Figure 6-26: Here's my default set of editing tools

Want to know what mine are? Here's the default list I use: Histogram, Light, Color, Sharpen, Definition, Vignette, and White Balance. With these sliders, I can quickly enhance the bulk of my images. Everything fits nicely in the Adjustments panel. And if I need to add something, such as Black & White, I can do so quickly.

Edit Your Best

There is no limit to the amount of time you can spend editing your pictures. And as you can see from this chapter, Photos has plenty of tools to enable that process.

I recommend that you first choose your favorites from a shoot and then

spend your valuable time editing those. In other words, work on your best stuff. The other files are always there if you have the time to address them. But, by focusing on your best shots and making them better, you can impress others . . . and get some sleep too.

Oh, and One More Thing . . .

When we spend a lot of time working on a picture, we sometimes get attached to it. There are things we love about the image, and there may be other aspects that we don't like but can't fix.

When you show pictures to friends and family, don't point out the things you don't like. Let me repeat this: *Don't point out the things you don't like!* Chances are good that only you notice the small flaws in your artwork. My experience has been that others don't even notice the things that bug me—that is, unless I point them out. Then that's all they'll focus on.

Accept compliments gracefully, critique humbly, and never, ever point out the flaws.

OK, let's move on to editing extensions. These are going to rock your world.

Editing Extensions

Editing extensions are one of those delightful surprises that make me smile. They're like finding an extra two cookies in the bottom of the jar.

This is the part of my job I like. I'm the one who gets to introduce you to Tonality, Aurora HDR, and DxO Optics Pro. And that's what we're going to do here: learn how editing extensions work, and then explore a few of my favorites that I use regularly.

Better Living Through Extensibility

As you can imagine, I own quite a few cameras. My SLRs from the '80s and '90s use film to record images. Those cameras are exactly the same now as they were decades ago. I load a roll of 35mm Tri-X, crank the advance a few frames, and I'm ready to shoot. As for the electronics, they have a light meter and that's about it.

On the digital side, I shoot a lot with an Olympus OM-D E-M5 Mark II. I've owned it for a little over a year, yet it's a different camera today than when I bought it. Since my initial purchase, new features have been added via

firmware updates. And we're not just talking about bug fixes. With firmware 2.0, the enhancements included focus bracketing, simulated optical viewfinder, 4K time-lapse movies, and live composite using OI.Share. A number of new features for video capture were added too.

This is the type of technology I appreciate. Instead of planned obsolescence, we have enhancement through extensibility.

Photos for macOS takes this a step further. Unlike Olympus, which must create all of the firmware updates in house, Apple opened an upgrade door to approved developers. So as Apple

Figure 7-1: The editing extensions that I currently have available in my Photos app. Some I like better than others. Read on to find out which ones.

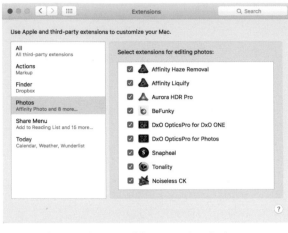

Figure 7-2: Managing my editing extensions in System Preferences

continues to evolve its software according to its vision, independent companies can also enhance Photos' capabilities in other ways. This third-party software, which is the focus of this chapter, is called *editing extensions*.

The Photos approach to extensibility is better than what we had with Aperture and iPhoto. Yes, Aperture had plugins. But they were really separate apps that could talk to Aperture. Plus, RAW files had to be converted to another format for the handoff. So you typically ended up with multiple files for a single image.

Editing extensions feel like they operate within Photos. The Apple interface is replaced by that of the third-party app in a very seamless way. And when your enhanced image is returned to the Photos library, it behaves like a native file, including being able to view the original by pressing the M key.

Now there are some caveats. For example, if you use RAW files with some of the extensions, the process isn't as smooth as you might wish. Instead of the edited image being returned to Photos, you have to save it somewhere else. And quite honestly, some extensions are better than others.

That being said, I absolutely love most of the software I cover in this chapter. And I can't imagine my Photos experience without them now. So let's take a look together and see if anything resonates with you.

Not All Editing Extensions Are Created Equal

On last count, I had more than a dozen editing extensions loaded on my Mac. I like most of them, and I'm going to highlight 10 that I use the most. The extensions I explore in this chapter include:

- Affinity Haze Removal
- Aurora HDR
- BeFunky Express
- DxO Optics Pro for Photos
- DxO Optics Pro for DxO ONE
- External Editors for Photos
- Noiseless CK
- Snapheal
- Tonality
- Markup

These extensions add a lot of capability to Photos for macOS. Some of them expand the functionality already present in the native app, such as Tonality making the black-and-white conversion experience even better. Other extensions introduce new functionality, such as high dynamic range photography with Aurora HDR Pro. And there was one introduced by Apple with Photos 2.0 that's unlike any of the others. It's called Markup, and I'll cover it too.

We'll begin our journey with how to load and manage this software, and then I'll dig into the individual applications.

Finding and Managing Editing Extensions

You can download third-party software for Photos from a couple of places. My favorite is the Mac App Store. Software purchased here has been vetted, is automatically updated, and can be shared across computers. If you buy a new Mac, you simply have to log in to your Apple account, and the latest versions of the software you purchased are ready to add with just a click of a button.

The downside to the Mac App Store has been that the versions offered there sometimes aren't as fully featured as what are available from the developer's own site. That's why in my reviews I sometimes use the Mac App Store version and at other times I use what's offered directly from the developer. The decision almost always comes down to lower price and fewer features versus pro capability. If I feel I don't need the additional features, then I opt for the ease and cost savings offered by the Mac App Store. Other times, I pony up and get the pro version. More on this as we discuss the individual extensions.

As such, I recommend that you check the developer site before automatically downloading a version from the Mac App Store. Why? The link to the developer site is always listed in the store description, so you can pop over there and take a look. Spending these few extra minutes will ensure that you make the right decision for your workflow.

I know paying less sounds good initially, but you may want some of those features that have been omitted and you may be willing to pay a bit more to have them all. If after your research, all things are equal, then go with the App Store. It's just easier to manage.

Once you've purchased an editing extension and have installed it on your Mac, you can manage it in two ways:

1. From within Photos: With an image open in Edit mode, click on the Extensions icon at the bottom and then click on More.

2. Go to System Preferences > Extensions > Photos. Click on the Extensions icon in the third row, and then click on Photos.

With either of the above methods, you will get a popup showing your extensions. There you can turn your extensions on and off by checking/unchecking the boxes. Those that are active will appear in the Extensions popup in the Edit view of Photos for macOS.

To use any of these extensions, open a picture in Edit mode of Photos, and then click on Extensions at the bottom of the icon list. It's right below Retouch. Within moments, your image will appear in a new user interface with additional options. Once you've applied the edits that you want, click OK, and you and your picture will be returned to the Photos native editing environment.

This workflow served me best when editing JPEGs. With some extensions, RAW files take a left turn. I'm not trying to steer you away from RAWs here. In fact, with DxO Optics Pro, you need a RAW file to get the most out of the app.

But I do want to set the stage properly. By nature, RAW photography is more adventurous. I would say that's true here also. So read what the developer says before clicking the Buy button.

OK, that's enough chatter for now. I'm champing at the bit to start playing

with this software. So let's go through this list, in alphabetical order, and learn a bit more about these tools.

ACTIVATE YOUR EXTENSIONS

After purchasing extensions, there are two ways to activate them:

1. From within Photos: With an image open in Edit mode, click on the Extensions icon at the bottom and then click on More.
2. Go to System Preferences > Extensions > Photos.

Affinity Haze Removal

Software: Affinity Photo
Editing extension: Affinity Haze Removal
Download from: Mac App Store
Price: $49.99
Website: affinity.serif.com/en-us/photo

Affinity Photo is a full-featured image editor that includes six editing extensions, one of which is reviewed here. When you download the application, the editing extensions are made available to your system. You can turn them on and off in System Preferences.

Haze Removal is a terrific tool, although a single-minded one. Lightroom subscribers have been enjoying a similar feature, and now Photos users have access to it. Once you choose

your image and then select Affinity Haze Removal from the Extensions popup menu, the application loads your picture and presents you with a few basic controls.

Speaking of loading, Haze Removal isn't the fastest kid on the block. At first, I thought something was wrong as I stared at the Affinity logo during the loading process. But finally my image appeared, and all worked well going forward.

The two main sliders, Distance and Strength, intensify the effect but do so in slightly different ways. Start with Distance to remove the appropriate amount of haze, and then fine-tune with the Strength slider. I find myself going

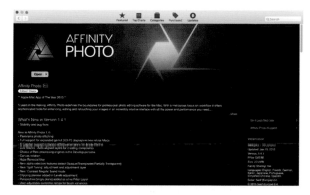

Figure 7-3: Affinity Photo in the Mac App Store

back and forth between the two to find the perfect balance. It's actually quite fun.

Using the little check box at the bottom of the panel, I leave Split View

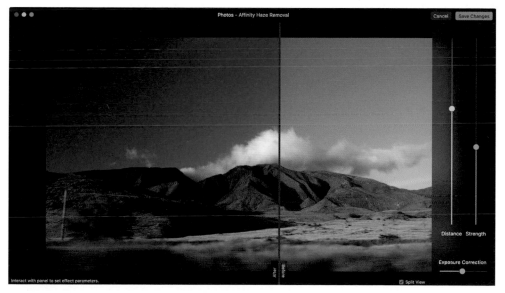

Figure 7-4: Using the Affinity Haze Removal editing extension

turned on so I can see the effect and original image presented side by side. And you can drag the vertical line left and right to show more or less than half the image. This really helps you appreciate how powerful Haze Removal is. Use Exposure Compensation for the finishing touch, and then click the Save Changes button.

You're returned to Edit mode in Photos. To see the difference, press the M key to toggle between before and after. Most of the time, you should see quite a difference. You can continue editing with other Photos tools.

I tested a RAW file, and there were no hiccups. So this workflow seems the same for both JPEGs and RAWs.

Affinity Haze Removal is only one of the editing extensions that come with the Affinity Photo application; it's an-all-or-nothing proposition. I think Affinity Haze Removal is the best of the bunch, but since the others are there, you may want to experiment with them also.

Aurora HDR Pro

Software: Aurora HDR
Editing Extension: Aurora HDR Pro
Download From: Developer site
Price: $99 (App Store price: $36.99)
Website: aurorahdr.com

Aurora HDR comes in two flavors. The streamlined version is available in the Mac App Store, and the Pro version can be purchased at the developer site.

Both include a Photos editing extension. There are differences in the two versions, however.

The App Store download of the app doesn't support RAW files (as of version 1.1.1). This means there isn't RAW support in the extension either. So if you want it, this is one of those situations in which you should visit the developer site for the more expensive Aurora HDR Pro. That's what I'm using here, because I wanted the RAW support.

The Pro version also offers gradient and luminosity masking tools, more presets, and plugins for Lightroom, Aperture, and Photoshop.

For my testing, I started with a JPEG that we had already worked on with the native Photos tools, the landscape shot of the tufa at Mono Lake. Overall, I thought the shot was looking pretty good. So let's see what Aurora HDR Pro can do with it.

You may be wondering why I'm working with only one frame. That's because the editing extension versions of Aurora HDR allow you to work on only one image at a time. This is a constraint created by the Photos app, not Aurora HDR. If you want to make a composite of multiple pictures, then I recommend that you export the master files from Photos and then load them into the standalone version of Aurora HDR or HDR Pro. You can bring the finished product back into Photos afterward for cataloging and sharing.

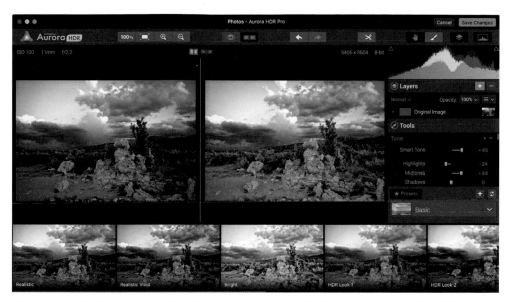

Figure 7-5: A side-by-side view of the Mono Lake landscape, with the original on the left and HDR version on the right

OK, back to our tufa landscape. I think the best way to start is to browse the presets to find one that comes close to your vision for the image. The presets are gathered in groups, such as Basic, Landscape, and Dramatic. Look for the Presets heading in the adjustment panel on the right side of the interface. Click on it, and the various categories will be displayed.

When you pick a preset by clicking on its thumbnail, the effect is applied to your picture. Mouse over the thumbnail, and a little slider will appear at the bottom of it. That's a fader, allowing you to control the amount of the HDR effect. When you first choose that effect, it's applied at 100 percent. But you can back off to lesser degrees using the slider.

In the top toolbar, you'll see two rectangles positioned side by side. That's the Compare button. Click on it, and another set of buttons appears beneath it, presenting you with two different options for comparing the original shot with the processed one.

On the right side of the interface, above the presets, there's a collection of tools to help you further refine your image. The Mac App Store version features fewer tools than displayed in the Pro version. Either way, if you like to tweak, there's plenty here to keep you busy. If not, the presets should provide you with a healthy variety of options.

When you're finished, click the Save Changes button. Aurora HDR will process the image and hand it back to Photos. Even though you're only

working with one frame, this editing extension is powerful. I've been very impressed with its results. My tufa picture, for example, was improved just by using a preset.

BeFunky Express

Software: BeFunky Express
Editing Extension: BeFunky Express
Download From: Mac App Store
Price: $4.99

I'm not sure who was in charge of the naming of this software, but it's not funky at all; it's very useful, especially for portrait photographers.

The editing extension is a bit of a departure for these developers, since they're mainly online software folks. If you go to befunky.com, you'll see they have both free and subscription versions. The editing extension, however, is a straight $4.99, and it provides some helpful tools:

- Auto Fix
- Skin Smoothing
- Skin Tone
- Teeth Whiten
- Eye Brighten
- HDR

I noticed on the reviews that some users were complaining about the lack of a zoom tool. I don't know whether that was an earlier version or whether people didn't understand the interface,

so I'll start there and then touch on the tools themselves.

When you first load the image into BeFunky, it will be in "fit to frame" mode. To zoom, either pinch outward on a trackpad or click and drag the gray dot at the top of the interface. As you drag the dot to the right, the magnification will increase. You can also use the scroll wheel on a mouse to control the magnification. At this point you'll need to reposition the image. Hold down the spacebar, and drag the picture so it's framed properly for your work.

Now you're ready to do some adjustments. Once you apply an edit, use the circular "before and after" arrows to see how the image looks without the edit and then with it. They're a bit unusual, interface-design-wise. In fact, I'm beginning to understand the "funky" moniker.

Here is my review of the various tools:

- **Auto Fix** – I didn't find this very useful overall. But I'm guessing it works better on some shots than others. When you click on its icon, it makes a fix and presents an intensity slider for fine-tuning. If you see something you like, click Apply. Otherwise, move on to the next tool.
- **Skin Smoothing** – This adjustment is helpful for areas that show a bit too much texture or shine. Choose your brush size and hardness, and then paint only in the areas that need

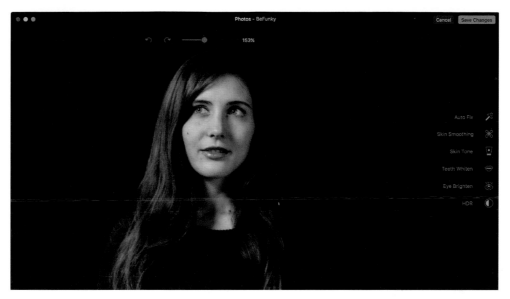

Figure 7-6: A collection of helpful tools for portrait photographers

work. You can then move the Texture and Smooth sliders to achieve the desired effect. There isn't an erase tool, but you can start over with any of the sliders by clicking on another tool and not saving your changes. I'll warn you now, be conservative with the Smooth Amount.

- **Skin Tone** – This brush is very handy for bringing bright areas into alignment with the rest of the face. I find myself using it most often on the shine that sometimes appears on the forehead. Just work on a single area, and then move the Tone Amount slider until things fall into line.

- **Teeth Whiten** – Set the brush size and hardness, and then paint on the teeth. The Intensity slider helps you apply the correct amount of

brightening. A word of caution here: Don't go crazy with this! A little brightening is good. Too much is just plain scary.

- **Eye Brighten** – I like this tool for adding a bit more light to the eyes. It works the same way as Skin Tone and Teeth Whiten. This one really works well.

- **HDR** – Having high dynamic range was a bit of a surprise. HDR? For portraits? But then I started playing with it, and I do like it. Basically you can control the shadow and highlight areas here and adjust the color a bit too.

A good tip is to remember to zoom in and out while working on an image. This serves as a bit of a reality check.

Sometimes corrections that look good zoomed in have an unnatural appearance when you move back a bit.

The other thing I've noticed is that the changes you make in the BeFunky interface become accentuated when the image is processed and returned to the Photos Edit mode. You'll probably be surprised the first time you make this journey. So, I've learned to be very conservative in BeFunky, and by doing so, the images are looking pretty good when reentering the Photos world.

DxO Optics Pro for Photos

Software: DxO Optics Pro
Editing Extensions: DxO Optics
 Pro for Photos, DxO Optics Pro for
 DxO ONE
Download From: Mac App Store
Price: $9.99 for Photos version; free for
 DxO ONE version
Website: www.dxo.com/us/photography/
 photo-software/dxo-opticspro-photos

Even though DxO Labs has two separate editing extensions—a general purpose one for a variety of cameras, and the other specifically for the DxO ONE camera—I'm going to talk about the general-purpose version, because other than the camera support (and price), they're about the same.

It was smart of DxO to offer a free version for those who have purchased their DxO ONE camera. For everyone else, however, I think the DxO Optics

Pro for Photos is worth a look, and worth the $9.99 price tag. This editing extension is for RAW shooters who want optical corrections, plus a few goodies, to maximize the quality of their captures.

The star of the show is Optical Corrections: the ability to correct distortion based on a profile for your camera and lens. This is something Aperture users craved, and they were jealous of their Lightroom counterparts who had this. And it works well. If your camera is supported, it will appear in the Optical Corrections box. If you don't see anything there, you may have to open it by clicking on the down arrow.

You can also check online to see if your camera is supported by visiting http://tinyurl.com/hvszx9m.

You can turn off and on Optical Corrections by clicking on the blue circle. I generally saw a noticeable difference between the original image and the one that's adjusted. For many photographers, that's probably worth $9.99 right there.

Beyond that, however, you also get tools for White Balance, DxO Smart Lighting, Noise Removal, and DxO ClearView. Each has a default correction that's applied automatically, and each can be fine tuned by clicking on the respective down arrow to reveal more options.

Here's a bit more about each tool:

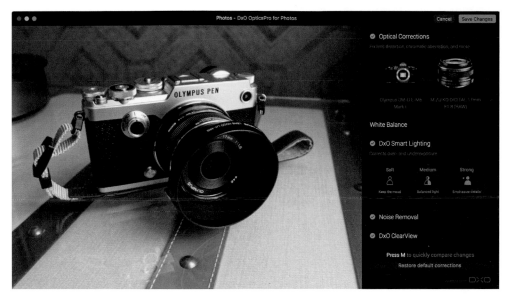

Figure 7-7: DxO Optics Pro for Photos has some terrific tools, including the headliner, Optical Corrections

- **White Balance** – Nothing special here that you don't already have in Photos. The nice thing about it is, however, if the color is off, you can fix it here to better judge the other corrections in DxO.
- **DxO Smart Lighting** – Helps correct exposure problems via three presets. It's pretty intelligent, and one of the presets will usually look darn good.
- **Noise Removal** – I think this is an excellent bonus, getting an easy-to-use noise removal tool as part of the bargain. Again, like the other adjustments, there are additional options if you click the down arrow to reveal them.
- **DxO ClearView** – This is another of those magic algorithms, much like the haze removal tool offered by Affinity

Photo and Lightroom. There are three different options here, each wiping away more haze than the previous one.

DxO Optics Pro is designed for RAW files. So make sure that you've selected Use RAW as Original (Image > Use RAW as Original) in Edit mode before sending the picture to the DxO editing extension. If you don't have a RAW version of a particular image, you can still use this editing extension. The benefits aren't as obvious, however.

External Editors for Photos
Software: External Editors for Photos
Editing Extension: External Editors for Photos
Download From: Mac App Store
Price: $ 0.99

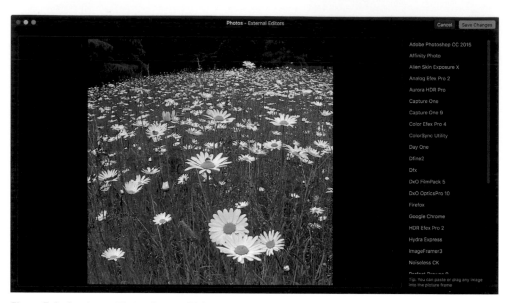

Figure 7-8: Send your Photos for macOS image to any editor you have loaded on your Mac

Not only is External Editors the most affordable editing extension in this lineup, but it is also one of the most interesting. They propose that a Photos user can send any image from inside the user's library to an external editor, make adjustments there, and then return the image to the Photos library. Sounds promising, doesn't it?

So, even though Adobe doesn't make an editing extension for Photoshop, a Photos user can send an image there, work on it, and have it land back in their Photos library. There are a couple caveats, however. I'll touch on those in a minute.

Speaking of Adobe, let's test this extension with Photoshop CC. I selected External Editors from my list of extensions and was presented with a window that had my photo on one side and a

list of all the editing applications on my Mac running down the other. I selected Photoshop CC from the top of the list.

The image was opened in Photoshop, and I converted it to black and white there. I then selected Save. At first, I didn't think anything happened, so I closed the Photoshop window. Behind it, however, was my black-and-white flower picture in the External Editors window. Wow. I clicked on the Save Changes button, and I was returned to the Photos Edit mode.

Here's the real test: I pressed the M key, and my original photo was displayed. And when I clicked on the Revert to Original button, I was returned to my original image. It worked!

All ran smoothly as long as I stuck to JPEGs. RAW files were a different matter, and neither of my favorite external

Figure 7-9: The Pro version of Noiseless CK

editors—Photoshop or Alien Skin Exposure X—could handle the return trip to Photos when starting with RAW files. (Yes, this is the caveat part of the show.) Also, if you create adjustment layers in Photoshop you'll create problems for this workflow. So you'll want to stick with single-layer work when using this extension.

You'll have to experiment with your favorite imaging apps to see how the round trip works with various combinations—but, the basic functionality is there. And for 99 cents, this editing extension is a deal for JPEG shooters.

Noiseless CK

Software: Standalone or with Macphun Creative Kit
Editing Extension: Noiseless CK
Download From: macphun.com

Price: $59 (watch for specials, also bundled with Creative Kit)

If you want to get serious about noise reduction in your Photos for macOS environment, then Noiseless CK is an excellent solution.

You might be tempted by the cheaper version in the Mac App Store, but if you want the best experience, I recommend purchasing the full version of Noiseless CK from the Macphun site, either as a standalone or as part of the Creative Kit. This is particularly true if you want to edit RAW files. The version I'm showing you here was downloaded from Macphun.

As you look at the interface, you'll see options for Presets and Adjust on the top right. Most photographers will be just fine working in the Presets area.

Not only does it offer you ten options for nearly every type of photograph, but each includes its own intensity slider to fine-tune the correction.

If you really want to get your hands dirty, then click on the Adjust button. Here you have 17 sliders to play with under the categories of Noise Reduction, Structure, Details, Filter, and Overall Opacity. Terrific stuff for the noise-reduction aficionado, but probably overkill for the average shooter who just wants to control unwanted artifacts in their images.

You can zoom up to 200 percent, and you can view the corrected image with the original side by side.

Even though the list price for the Pro version is $59, I've noticed that Noiseless CK goes on sale regularly. So you might want to keep an eye on the Macphun site for specials. I bought it for $29.

Snapheal

Software: Standalone or with Macphun
 Creative Kit
Editing Extension: Snapheal
Download From: macphun.com; Mac
 App Store
Price: $19

I think of Snapheal as the Swiss army knife of image correction. You can clone, erase, brush in localized edits, retouch, and use global adjustments. If there's a missing editing tool in Photos for macOS, then Snapheal probably has it.

For this review, I'm working with the version I purchased from the Mac App Store.

There are three basic categories of adjustments: Erase, Retouch, and Adjust. Click on the category you want to use at the top of the editing panel on the right side of the interface. I'll start with Adjust, on the far right.

- **Adjust** – Contains many of the standard global corrections that you're familiar with, such as exposure, color temperature, shadows/highlights, sharpen, clarity, and denoise. You wouldn't purchase Snapheal for these because they're already present in native Photos. But it is nice to have them as you're working on an image in this interface. There's a reset button located at the bottom of the panel if you decide you don't like the corrections you made.

- **Retouch** – Is far more exciting. Here you can paint in adjustments for color, luminance, clarity, and sharpening. Yes, it's localized editing! Set the slider to your best guess, such as adding more exposure, choosing your brush, and painting in the correction. Click on the Mask button to see the affected area. If you need to clean it up, the erase brush will help you remove any overspill. You can also erase the mask altogether by clicking on the trashcan icon.

Figure 7-10: Retouching in Snapheal

Once you have a particular area to your liking, click on the Apply button. It is locked in at this point, and there isn't an undo after you've applied the edit. One quirk of the application that I've experienced is that if you try to apply sequential edits, it will stop responding at some point. It's almost like it runs out of memory. So in this regard, I think it's fine for one-off localized adjustments, but not for extended work like you can do in Photoshop. There is a Reset button, but it's only effective before Apply, not afterward.

- **Erase** – Is the most magical of the editing panels. You literally paint on an unwanted object and then click on the Erase button, and Snapheal removes the object and replaces it with visual information around it. It's like a content-aware adjustment.

There are three different erasing modes and three precision levels. You can experiment with them after you press the Erase button to see different versions of the correction. Once you see what you like, that's it. There's no apply button, and more importantly, no undo.

You can compare your edits with the original by clicking on the Eye icon or view the changes side by side. There's also the standard zooming controls in the upper-left corner.

Once you click the Save Changes button, you're returned to the editing environment in Photos. Here you can press the M key to see the image before adjustments, and you can click

on Revert to Original if you decide you didn't like the work you did in Snapheal.

Overall, Snapheal is a powerful, sometimes magical editing extension for Photos. But it's not without its quirks. The lack of undo in the Erase panel is curious. And there are times where it's finished working before you are. So in these instances, it isn't a Photoshop replacement.

But for quick retouches that you can't accomplish with other tools, it can be very useful.

Tonality

Software: Standalone or with Macphun Creative Kit
Editing Extension: Tonality
Download From: Mac App Store
Price: $19.99

Tonality by Macphun is the most exciting black-and-white converter I've seen since Nik Software introduced Silver Efex Pro quite a few years ago. You can download a version of Tonality from the Macphun site that includes plugins for Aperture, Photoshop, and Lightroom. I opted for the inexpensive version from the Mac App Store that has all of the primary features, plus it serves as an editing extension for Photos.

If you've used other Macphun software, such as Aurora HDR, then Tonality should feel comfortable from the get-go. You have a variety of preset categories to choose from, including Basic,

Architecture, Portrait, Dramatic, Outdoor, Street, Vintage, Film Emulation, Toning, and HDR. Each category offers a number of tempting presets that you can use as a starting point from which to venture forward, or you can stop right there.

When you mouse over a selected preset, a fader slider appears, enabling you to control the amount of effect that's applied. But there are so many more tools on the right-side adjustments panel, including Tone, Color Temperature, Clarity & Structure, Color Filter, Tone Curve, Split Toning, Glow, Lens Blur, Texture Overlay, Vignette, Grain, Picture Frames, and Layers. It's really incredible what you can do with this editing extension.

Tonality had no problem editing my RAW files and returning them safely to Photos, although it did take a little bit longer to process those images.

Along the top toolbar, going from left to right, there's also a cropping tool, before and after comparison, zooming, histogram, brushing, and even a graduated screen filter. This app seems to have everything you'd need, and more, to create beautiful monochrome, split-toned, and HDR images. It's one of my favorites!

Markup

When I first started working with the beta version of Photos 2.0, I noticed a mysterious addition to my Editing Extensions list called Markup.

Figure 7-11: I was able to create this illustration using the Markup Editing Extension

At first, I didn't pay it much attention. After all, that's not really a scintillating name. And I had other more pressing matters to deal with. Then one evening I decided to see what Markup was all about. And boy, was I surprised.

Markup enables you to draw lines, add callout arrows, place text, add shapes, and scribble a variety of doodles on your pictures. The example I'm sharing with you here shows me describing the contents of my everyday camera bag. And creating this illustration was fast and easy.

To create yours, begin by choosing an image and going to Edit mode. Then select Markup from the Editing

Extensions list. A toolbar appears at the top of the interface that lists these options moving from left to right:

- Sketch
- Shapes
- Text
- Shape Style
- Border Color
- Fill Color
- Text Style

For my illustration, I started by clicking on the Text tool to make a text box appear. I typed my first callout, highlighted it by double-clicking on the word, and then clicked on Text Style to

Figure 7-12: Formatting the text in Markup

format it. I could reposition the words by clicking and dragging.

To add the arrows, I clicked on the Shapes tool and selected the arrow icon. An arrow appeared that I could angle in any direction. I could reposition it, or make it longer or shorter.

There are all sorts of goodies in Markup. I found a magnifying glass in Shapes that lets you show detail better. It's not just for viewing; it can actually become part of the illustration. Next to it is a border tool.

The frosting on the cake is that Markup is non-destructive, just like the other Editing Extensions. So I can see "before and after" by pressing the M key in Edit mode, Revert to Original works, and, if I want, I can return to Markup to edit words, change shapes, or add new ones.

This is an incredible tool that is both fun and wildly useful.

Which Editing Extensions Are Right for You?

As I was working through this list, I was thinking about which editing extensions were right for me. I like the lens corrections that come with DxO Optics Pro. Most of the files I run through Photos, however, are JPEGs, and DxO really shines with RAW files. But it's only $10, and I like the ClearView slider too. So, it's terrific for when I do shoot RAW and still useful the rest of the time.

Tonality solves a different problem for me. One of the reasons I was initially hesitant to give up Aperture was because of the plugins I had for it. At the top of that list was Silver Efex Pro for my black-and-white work. Tonality

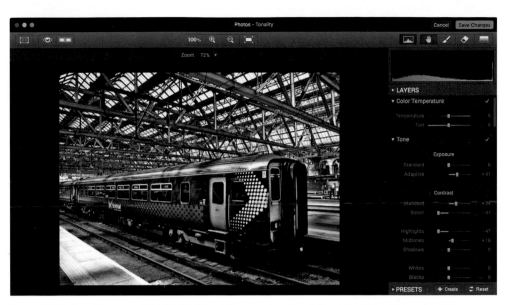

Figure 7-13: Tonality is great for black-and-white work, but the split-toning tools are excellent too

is different in many ways, but for me it scratches a similar itch. It helps me make beautiful monochrome and split-tone pictures. And realistically, I think it helps me be more creative in my postprocessing. The price is reasonable at $19.99.

But to be honest, I find most of these extensions interesting. And new ones are emerging all the time, such as Pixelmator Retouch, which I'm currently testing.

So, what are the things you'd like to do with the images in your Photos library? If you shoot portraits, then BeFunky should be considered. Are you a high ISO shooter? Then Noiseless CK might be a good addition. Put together a workflow that makes you want to sit down at the computer and produce beautiful photographs. Let's hope that one or more of these extensions will fuel such inspiration.

8

Outside the Mac

To this point, we've been focusing on using Photos for macOS on a computer. But one of its strengths is its capabilities beyond the Mac. In this chapter we'll wander away from home to explore iCloud, photo sharing, exporting, and backing up your pictures.

The Flight Home

I have a few basic wishes for all people. At the top of the list is good health. I believe that if we have health, every other obstacle can be overcome. And because I'm a romantic at heart, I want others to have love: family, friends, and, if you're lucky, partnership. That adds so much to life.

My third wish might surprise you: a comfortable place to live. No matter what happens outside of the house, having a comfortable home to return to is a gift indeed. And a good way to appreciate what you have is to occasionally leave it.

I've always loved travel—not surprising for a photographer. But I didn't find my perfect home base until 1989 when I moved to Northern California. Before then, when I would return from a trip, I was always a bit sad. I remember looking out the airplane window thinking,

"Vancouver was so beautiful; I wish I didn't have to go home yet." During those times, travel was both a delight and a disappointment. Fun to be away. Reluctant to come back. So I knew I had to change that. And one day I drove to Santa Rosa, CA, and never looked back.

Relocating changed my view of travel. Now everything is a win/win. I'm happy to explore the world, and I'm thankful to return to such a beautiful place. It's balanced now.

To some degree, that's what we're trying to accomplish here in this book. Pictures are a big part of our life. We can actually share our vision—what we see through our eyes—with someone else. That's incredible.

Figure 8-1: Coming home

For years, the primary method of sharing digital images was attaching them to an email. Virtually everyone knows how to do that. But it misses in some circumstances. What if you want to show something to the person next to you on the bus? Are you going to send them an email when you get home?

And how about events that happen over time, such as the birth and growth of a grandchild? Do you really want to go back through dozens of emails to assemble that history? Wouldn't it be easier to just have one spot that grows as does the child?

And beyond sharing, these memories need to be protected. It's so easy to lose your smartphone. Don't let last year's events drive off on the seat of a cab.

When I leave town, I lock the doors and arrange for someone to watch over my home. Then I can strike out into the world and embrace new experiences, confident that my home will be waiting for me when I return.

This chapter is about protecting the home for your photographs, while at the same time learning how to share them more easily with others. Photography should live beyond the hard drive. Let's strike out into the world together.

iCloud Photography

My theory as to why Apple had to start over with Photos for macOS is because the vision was to have cloud connectivity be part of its DNA. Adapting Aperture and iPhoto no longer made sense. Instead, bring everything together so your images are available regardless of location or which Apple device you're using.

I'm starting with iCloud in this chapter because I feel it's the most important tool for both automatically backing up your images as well as sharing them. We will explore some of the more traditional methods too. But, let's start with what I believe is the reason we're using Photos in the first place.

What Is iCloud?

Cloud computing means there's a device somewhere else that stores your data, and you connect to it via the Internet. The devices that are in your physical possession, such as the Mac, iPhone, and iPad, can communicate with the remote storage device.

It's like having a condo in Hawaii (or a condo any place): lots of other people are staying or living in the building, and you have a small chunk of that space for yourself.

Apple's version of this is called *iCloud*. And the minute you purchase an Apple device, you have access to this online storage. Every customer gets 5 GB of free storage space to stash pictures and documents. And if you need more, you can get 50 GB for 99 cents a month. That's a lot cheaper than a condo in Hawaii. Maybe I should rethink my metaphor.

What I've learned, though, is that a lot of folks with Macs and iPhones don't fully understand this membership. And as a result, they don't take full advantage of its benefits.

Well, that stops now. I'll begin with the most important aspect of this service, backing up, and then I'll move into sharing. iCloud is fantastic, and you'll want to take full advantage of what it has to offer.

iCloud Photo Library

This feature automatically uploads and stores images to your iCloud account. For the smoothest experience, have all of your Apple devices running the latest version of the operating system: at the time of writing, macOS for your Macs, and iOS for iPhones, iPads, and Apple TV.

Next, you want to check the settings on each device to ensure it is logged in to your iCloud account and that iCloud Photo Library is enabled. Let's start with the Mac.

Go to System Preferences, and click on the iCloud icon in the third row. If you're not logged in to iCloud, now would be a good time to do so. Make sure the Photos box is checked. If it isn't, do it now. Then click on its Options. I recommend that you check all three boxes as shown in figure 8-3. Then click the blue Done button.

Back in System Preferences, I recommend that you turn on iCloud Drive

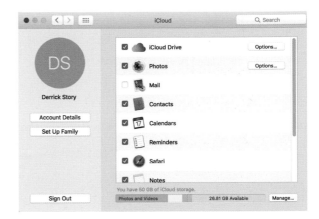

Figure 8-2: Check your iCloud settings in System Preferences on your Mac

Figure 8-3: I recommend checking all of these boxes

also. Once you do, click on Options to ensure the Photos Agent.app is also checked. iCloud Drive isn't photo specific. It feels a bit like Dropbox, letting you store all sorts of stuff in your cloud account.

If you have an iOS device, especially an iPhone, you need to do the same

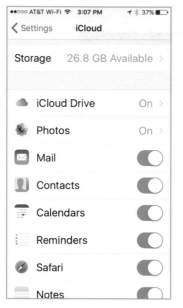

Figure 8-4: Be sure to set up your
iPhone too, if you have one

there. Tap on Settings, and then tap on
iCloud and check that you're logged
in. Tap on Photos. I'll walk you through
your options from top to bottom:

- **iCloud Photo Library** – Turn it on.
- **Optimize iPhone Storage or
 Download and Keep Originals** – Go
 with Optimize. This will save a lot of
 space on your iPhone.
- **Upload to My Photo Stream** – Turn
 it on.
- **Upload Burst Photos** – Leave it off.
- **iCloud Photo Sharing** – Turn it on.

If you're a power user, you may
want to choose different options than
what I am recommending. But if you
don't know either way, go with the

recommendations. By doing so, your
iPhone pictures will automatically
be backed up to your iCloud account.
Optimized versions of them will be
available on your phone, but the mas-
ters are always accessible via iCloud.
And you will be able to participate in
sharing, as I will discuss shortly.

Before you leave Settings, make
sure everything is turned on in iCloud
Drive also. If you have older devices that
you haven't upgraded, then turn on as
many photo-related iCloud options as
are available. Chances are good that
you'll still be able to participate in cloud
activities.

So, what do you get in return? Oh
my! Plenty.

Let's run a test. First, make sure all
of your devices are connected to the
Internet. Then take a picture with your
iPhone. Try to find something pretty or
interesting. Open Photos for iOS on the
phone, and check that your image is
there in the Photos tab (the one on the
far left at the bottom of the application
interface). If you see your picture, then
you know it's uploading to iCloud too.

Go to your Mac, and open Photos for
macOS. Scroll to the bottom of Moments
in the Photos tab. The picture should
be there also. If it isn't, just wait; unless
something has gone whackadoodle with
your Internet connection, the picture
should appear within a minute or so.

Once it does, double-click on it
and go to Edit. Convert the picture to

Black&White in the Adjust tab, and click Done. Now go back to your iPhone and look at the picture. It should convert to black and white before your very eyes (or sooner). Fun, isn't it?

Last step, while viewing your new black-and-white picture on your iPhone, tap Edit. Then tap on the red Revert text in the lower-right corner. You'll be warned that the edits are being removed. Yup, that's what we want. Tap Revert to Original. The photo goes back to color, not only on your phone, but everywhere else.

You can play this game for hours. And it shows how integrated your Mac and iOS devices are.

Plus, keep in mind that the picture you took was automatically backed up to your iCloud account without you having to do anything. This is the kind of archiving we want: mindless. So now, if you left your iPhone on the seat of a cab that's just sped away, you'll still be sad. Your iPhone is gone (at least for the moment.) But your pictures are not. Every important memory you recorded with that camera is tucked away safely in your iCloud account. And all you have to do to see them is log in via your Mac or iOS device. This is a beautiful thing.

iCloud Photo Sharing

I doubt whether anything will ever replace email attachments. But iCloud Photo Sharing can certainly augment

Figure 8-5: You can revert to the original image if you wish

email, and quite stylishly at that. I'm going to cover two basic types in this chapter: iCloud Photo Sharing and Family Sharing. The former is far more versatile than the latter. But I want to give a nod to Family Sharing anyway. Let's start with iCloud Photo Sharing.

This feature enables you to create an album that others can view. iCloud subscribers only have to accept your invitation to have the collection of images appear in the Shared tab of their Mac or iOS device.

Shared albums can be updated by you, and if you allow it, by subscribers too. And because it's a subscription, friends and family can also unsubscribe when they no longer need to see the pictures.

Figure 8-6: Creating a new shared album

You can share a single picture or a group of shots. Recently, I created an album to share with some of my photographer friends. All I had to do was open up the album, then click on the Share button, and choose iCloud Photo Sharing. A popup window appeared asking me if I wanted to create a new shared album or add these images to an existing one. I wanted new, so I clicked on New Shared Album.

In the next popup, I gave the album a name and then clicked on the blue + button to invite people from my address book. I could also type iCloud email

addresses instead. To finish, I clicked on the blue Create button.

When you do this, your invitees will receive a message notifying them of the invitation. They can accept or decline. If they accept, the album shows up in the Shared tab of the Photos app on all of their Apple devices. Every time you add pictures to this album, the recipients will be notified that there's new stuff to see. Adding photos is easy. Just select them, go to the Share button, click on iCloud Photo Sharing, and then click on the shared album that's displayed in the list.

You have a fair amount of control over how this community space is managed. Go to the Shared tab, and open an album by double-clicking on it. Next to the Share icon in the top toolbar, you'll see a new button that has the outline of a person. Click on it.

Figure 8-7: Invitees have the option to accept or decline

Figure 8-8: Options that you have control of in the settings window

A settings window appears with options for letting subscribers post, making this a public website, allowing notifications, inviting more people, and deleting the album itself. Checking the box to create the public website generates a URL that you can copy and share with anyone, iCloud subscriber or not.

More About a Public Website

For those of you who don't have iCloud accounts, a public website is a fantastic option. In fact, you should make one regardless. They are beautiful! Viewers can use the slideshow player, download images, and even go to Full Screen mode. All of this happens within the web browser.

A perfect example of putting this to use is a family birthday party. You have dozens of cute kid shots to show everyone. Create a shared album, invite the family iCloud members to it, and send the URL to everyone else. If other folks have pictures to contribute, they can do so (if they're participating on iCloud) and add to the fun. This album is available as long as you leave it posted, and it looks great on all devices. Now, regardless of how far away she may live, Mom can show off the pictures to her coworkers by opening the shared album that you created on her iPhone.

Figure 8-9: The public website is quite beautiful and easy to use

In my view, Shared Albums are an underutilized feature of Photos for macOS—in large part because many don't understand how easy it is to set them up. Now that you know, I encourage you to share some of your great photography with friends and family.

Family Sharing

Photography isn't the focus of Apple's Family Sharing, but there is one nifty photo-related feature. Family Sharing allows up to six people in a family to share each other's iTunes, iBooks, and App Store purchases without sharing accounts. In addition to a photo site, the service includes a family calendar and a shared Apple Music membership, if that's been purchased.

That's all great, but the thing I wanted to make you aware of is that if you do enable Family Sharing, Photos for macOS will automatically set up a shared album on everyone's account. Any family member can view and comment on the content, as well as add their own images.

If you have a bunch of shutterbugs in your clan, this could be fun.

FAMILY SHARING

If you enable Family Sharing, Photos for macOS will automatically set up a shared album on everyone's account. Any family member can view and comment on the content, as well as add their own images.

Exporting Pictures

Because of all the different ways we can share pictures using Photos, maybe exporting isn't the big deal that it once was. But there are still times when we need to transport an image out of Photos, using specific specifications, to our desktop or a folder. Here's how it works.

Using the Export Command

You won't find a button on the Photos interface for initiating an export. This task is reserved for the file menu: File > Export. There are three options here, and it's worth spending a minute understanding their differences.

Export One or More Photos

This is the most common choice where you can specify file type, size, and other parameters. Let's cover the options in each of them, and then I'll write a bit about their use.

- **Photo Kind:** JPEG, TIFF, or PNG
 - **JPEG Quality:** If you choose JPEG in Photo Kind, then Low, Medium, High, Maximum; if you choose TIFF you can export as 8-bit or 16-bit by checking the box
- **Color Profile:** sRGB, AdobeRGB, Other
- **Size:** Small, Medium, Large, Full Size, Custom
- **Info:** Two options to include metadata and location information

Figure 8-10: The Export command in Photos

- **File Name:** File Name, Title, Sequential
- **Subfolder Format:** None or Moment Name

So, how do you work this? Start at the top. What kind of image do you want to export? If you don't know, choose JPEG; it's the most common picture format. TIFF is sometimes selected because it's a lossless format, so it doesn't degrade when you edit and resave it. You might choose TIFF if you are sending an image to be published in print. TIFF files are larger, and that's primarily why they're not used online. PNGs are a common web format, but in most cases I think JPEGs are better because they take up less space on the drive.

JPEG Quality refers to how much compression is applied. The higher the quality, the less the compression and the bigger the file. Most photographers are satisfied with Medium or High. Low applies too much compression, and

Figure 8-11: Plenty of choices in the Export dialog box

because most cameras capture in that color space by default.

For size, Apple still uses its venerable Small, Medium, and Large choices that we first saw with iPhoto. But what do they mean? Well, Small is 320 × 240. That's really small. I consider that thumbnail size. Medium is 640 × 480. Fine for sticking in a web article, but too small for sending to a friend. Large is 1280 × 960, and that's a wonderful size for an email attachment and general-purpose sharing. The sizes I list here are based on my own testing with an original 16-megapixel capture at 4608 × 3456. So if your camera has different proportions for the sensor, these numbers could be slightly different, but should be essentially the same.

Fortunately, you can also set a custom size. Choose Width, Height, or Dimension (I recommend Dimension, which is really a confusing way to say longest side). Then add the number you want. This is what I use 90 percent of the time; I know exactly how long the longest side will be.

You can include the title, keywords, and description by checking that box under Info, next to Include. As for the Location information, think that one through. My default is to leave it unchecked. I might not want people to know the exact address when a child's birthday party was photographed. On the other hand, a vacation shot with location data can be useful to you and

the file sizes get a bit too big at the Maximum setting.

The TIFFs are automatically saved as 8-bit files, which is the most common setting. In rare instances, such as for high-resolution printing, you might want to take advantage of the 16-bit option. But unless you know you need it, don't. Those files are huge.

The rule of thumb for Color Profile is, if it's going online or for computer display, choose sRGB. Images for inkjet printing can be saved as AdobeRGB. That color space is a little larger. Interestingly enough, most online print services are calibrated for sRGB. That's probably

Figure 8-12: You can create a new folder on the fly to house your exported pictures

others. Choose the best option for the particular image.

And finally, for file naming, we have a couple of options for the picture itself and for a possible folder to put it in. Unfortunately we don't have the one choice I want for either of these, which is custom. So on export, I tend to select File Name from the File Name option (again, same labels for different things!) and None for Subfolder. If I want a subfolder with a name of my choosing, I wait until the next screen.

Click the blue Export button, and you get to choose the location where your pictures will be sent. In this standard Mac dialog, there's a New Folder button in the lower-left corner. Click on that, give your folder a name, make sure it's set up in the right place, and click on the blue Create button. Now all you have to do is click on the Export button

to finish the task. The image, or images (yes, you can export multiple files at once) will be placed in the desired location.

You might be curious about this. In my everyday life, here are the standard settings I commonly use:

- **Email Attachments:** JPEG, Medium, sRGB, Large, no Location Information
- **Facebook, Twitter, Instagram:** JPEG, High, sRGB, Custom: 1600 Dimension, no Location Information
- **Flickr:** JPEG, High, sRGB, Custom, 2048 Dimension, Location Information (if not someone's home)
- **Inkjet Printing:** TIFF, Adobe RGB, Full Size

Export Unmodified Original
Photos for macOS keeps all your master files safe in its library container. If you

want to export an exact copy of that image without any changes, choose Export Unmodified Original.

RAW files will be exported as RAW, JPEGs as JPEGs, and if you have RAW+JPEG pairs in your library, Photos will export them both. Unfortunately, they all have the same frustrating file naming options as we had before, so I suggest sticking with the original file name, and if you wish, create your own folder in the second dialog box.

There's an option to Export IPTC as XMP. That's a lot cryptic letters isn't it? This means that if you add keywords and description information (IPTC), Photos can send that out as a separate file that can be read by applications such as Lightroom. This option only makes sense for RAW files, since IPTC is already embedded in JPEGs. If you choose it, be sure to keep the original RAWs and the XMP files in the same directory, so applications such as Lightroom can meld this data upon import.

Export Slideshow

Your slideshow projects aren't confined to Photos for macOS. You can export them to share with anyone. Click on a slideshow project that you've created, and go to the Export menu. Export Slideshow is now available.

There aren't many options in the next dialog box. Basically, you can determine where it goes and have a choice of three resolutions: High Definition 1080p, High Definition 720p, and the practically useless 480p. The 720p is a good all-around choice. However, almost any modern device can play 1080p these days.

The last choice you have here is to automatically send the movie to iTunes. I'll leave that decision to you.

Alternatives for Backing Up Your Library

By default, Photos for macOS stores masters, previews, adjustments, projects, and metadata in its library container. Go to your Pictures folder and look for *Photos Library.photoslibrary*. You can back up this container to an external drive by drag and drop. Just to be safe, close the app first.

I have a system where I put the library in a folder identified by date. After about two or three of these backups to the external drive, I can begin to delete the older versions. I like to have at least two backed-up versions of my Photos library.

Keep in mind that this is in addition to what's stored in iCloud. You may be wondering, "Well, if I have my library stored in iCloud, why do I need to consider an external drive too?" Technically, you don't. The iCloud system is robust and automatic. Anything beyond it is

added insurance. But when it comes to my photographs, I figure the low cost of disk storage is an excellent policy.

REDUNDANT BACKUPS

Though the iCloud system is robust and automatic, I like to have at least two other backed-up versions of my Photos library. To me, this is added insurance. When it comes to my photographs, I figure the low cost of disk storage is worth it.

Photos for macOS is also compatible with Time Machine. If you're using Time Machine—Apple's answer to automating local network backup—then your pictures are included along with the rest of the data on your Mac.

The amount of redundancy implemented to back up your photos is a personal matter. But thanks to the all-in-one-container structure of the Photos library, it's easy if you want a little extra peace of mind.

Geotagging and Metadata

One of the wonders of digital photography is that cameras can record data as well as images. Smartphones are particularly good at this.

In this chapter we're going to explore that world. And yes, I agree, *metadata* isn't the most alluring term I've ever heard. But there are a few tricks here that I just don't want you to miss.

Some Things Just Don't Mix

One of my struggles in the past with analog photography was keeping notes about my work. As a young man, I was determined to improve as a photographer. My thinking was that if I took notes about the settings I used for each shot, then I could repeat my most successful images and get better.

Figure 9-1: There's a wealth of data in the Info panel

The thinking was sound. The doing of it was another matter.

My problem was that every time I'd fall into the creative zone and start taking good pictures, I'd forget to make notes about them. I'd be floating along on my artistic high, exposing frame after frame with nary a note jotted down. After the film was processed, I'd think to myself, "My, that foggy morning shot is wonderful. I overexposed that, right? I wonder how much?" Oh nuts.

The next time out, I was determined to do a better job with my documentation. I'd shoot a couple frames and then write down the aperture, shutter speed, exposure compensation, filter, and anything else important. Doing this seemed to put me on the wrong side of my brain. I ended up with great notes for terrible-looking shots. Well, at least I knew what not to do next time.

I never solved this problem during my youth. Fortunately, digital imaging came along and solved it for me. It's called metadata. And it's wonderful.

Every time I take a picture with my digital camera, it records a bounty of information: shutter speed, aperture, exposure compensation, white balance, flash status, focal length, camera name, lens used, the date, and on and on. And I don't have to think about it at all! Pressing the shutter button not only captures the picture, but also all of this other helpful information.

Then, as if metadata wasn't good enough, geotagging emerged. So not only did I know when I took a picture, but I knew where I was standing at the time. And software such as Photos for macOS can plot the location of those pictures on a map.

This was exciting to me. The nerd photographer could celebrate both the art and the science of his passion. "Others need to know about this too," I thought. I soon discovered, however, that not everyone shared my enthusiasm for location data.

I hope this is not the case with you. You understand what a big deal this is, don't you? And if so, you and I are going to have a great time exploring this topic.

And once you get excited about it too, I have just one piece of advice. This isn't really a good party topic. Trust me. I know.

The Info Panel

The Info panel is command central for all types of data: IPTC, EXIF, and location. It's easy to use. Click on a picture, use the keystroke Command-I, or click on the i button in the toolbar, if it's present. There it is. I'll start by walking you through this area, and then I'll show you a few geotagging tricks.

The Top Part: EXIF Data
The top one-third of the Info panel displays EXIF data—stuff written by

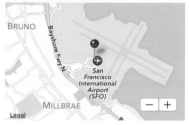

Add a Title

IMG_0693.JPG
January 28, 2016 9:26 AM

Apple iPhone 6s
iPhone 6s back camera 4.15mm f/2.2
1827 × 1827 635 KB JPEG

| ISO 25 | 4.15mm | 0 ev | f/2.2 | 1/1012 |

Morning at San Francisco Airport

Fujifilm X20 Morning
San Francisco iPhone 6S
travel

(+) Add Faces

San Francisco International Airport, San
Francisco, United States

BRUNO
San
Francisco
International
Airport
(SFO)
MILLBRAE
Legal

Figure 9-2: Click on a picture to select
it, and then click on the i button

the camera. The exceptions are at
the very top where it reads "Add a
Title" and where the favorite icon is.
I'll address those in the next section
discussing IPTC.

The file name is assigned by the
camera, but you have some influence
on the date by checking it in the cam-
era's settings menu. Daylight savings
and travel can cause an incorrect date
to be listed here. Fortunately, that
can be fixed both on the camera and
in this application. See the sidebar
"Adjust Date and Time" to learn how
to do this.

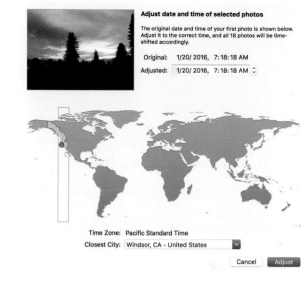

Adjust date and time of selected photos

The original date and time of your first photo is shown below.
Adjust it to the correct time, and all 18 photos will be time-
shifted accordingly.

Original: 1/20/ 2016, 7:18: 18 AM

Adjusted: 1/20/ 2016, 7:18: 18 AM ⌃

Time Zone: Pacific Standard Time
Closest City: Windsor, CA - United States ▾

Cancel Adjust

Figure 9-3: Correct those inaccurate timestamps with
this panel

ADJUST DATE AND TIME

If your camera's clock isn't correct, then
it will add incorrect metadata to your
pictures. Here's how to fix that in Photos.

First select the images that have an
incorrect time timestamp. The easiest
way is to click on the first thumbnail,
hold down the Shift key, and then click
on the last thumbnail in the series.

Then go to Image > Adjust Date and
Time. Enter the correct time in the
Adjusted box.

Click on the Adjust button. All of the
timestamps will be updated.

You can check your work by clicking on
any of the individual pictures and open-
ing the Info pane.

The next area is the camera information display. There's a lot here, including which camera captured the image, lens, metering pattern, aperture, file dimensions, file size, image format, ISO, and exposure value (EV). All of this data is stored with the image. This is the stuff I wanted back in the film days. And now it's added without any effort on my part.

The Middle Part: IPTC Data

Data-wise, you're not completely left out of the mix here; you can add information too. You can add a title, mark the image as a favorite, write a description, add keywords, and if appropriate, include face recognition data. This is all IPTC.

Most of it is in the middle of the panel. To add information, just type in the fields. If you want to add stuff to a batch of images, select them all, type your additions in the group Info panel, and the information will be added to them all.

The labels in the blue boxes are keywords. They can be typed in here, and

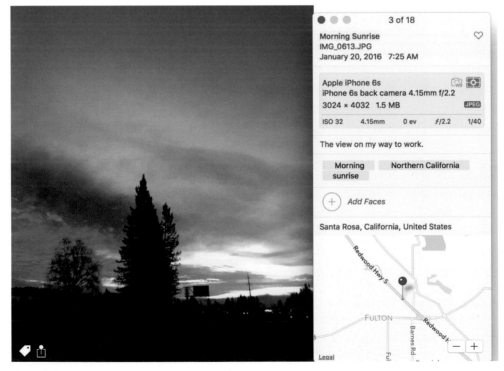

Figure 9-4: You can add your own data just by typing in the fields

when you separate them by a comma or press the Return key, they are entered into the keyword database. What does that mean? Photos has a decent tool for managing keywords. You can access it by going to Window > Keyword Manager or by typing Command-K.

The main reason why some photographers spend time adding keywords to all of their images is because it makes search better. If you have to constantly comb through thousands of pictures looking for specific shots, keywords can be a blessing.

Photos for macOS can search your library using keywords and many other bits of data too. So I wouldn't say that keywording is something that you have to do. But if you find yourself endlessly looking for images in your library, you'll benefit from this practice.

MORE KEYWORD TIPS

The Keyword Manager is a fast way to add or remove keywords from images in your library. Select the pictures you want affected, and open the Keyword Manager. The labels highlighted in blue means those words are in use for the selected images. If there's a minus sign in the label, then the keyword is used in some of the selected pictures.

(continued)

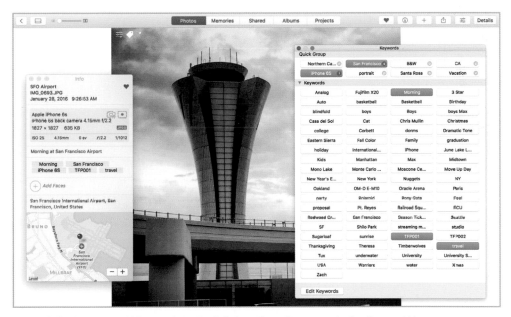

Figure 9-5: When you add keywords to the Info box, they also appear in the Keyword Manager

The Bottom Part: Location Information

Geotagging is the magical part of metadata. (I tried this line at a gathering once. My impression based on response was that I overstated my case a bit.) The GPS unit in your smartphone or camera records the coordinates of where you're standing when you press the shutter button. That information travels with the picture, along with the other metadata that I've discussed. When Photos for macOS sees those

coordinates, it translates them into a pin on a map . . . the very place you took the picture.

This capability adds a new dimension to our photography. Not only can we record when we took a picture, but also where. I'm particularly fond of this feature for travel. Seeing those pins in San Francisco, Las Vegas, Austin, New Orleans, New York, London, Paris, Glasgow, Beijing, and beyond strengthens the memories associated with the pictures.

I've heard people complain that photography robs us of life experiences. We're so consumed with getting the shot that we often miss the moment itself. I understand the point. And yes, balancing experience with capture is important. (This is particularly true on family vacations. Learned that one the hard way.)

But when I look at a thin slice of reality, recorded in a fraction of a second, whole days come rushing back to me. And seeing those days on a map just makes it better. That's what's happening in the bottom part of the Info panel.

So I'm sticking with my guns here. It's cool.

Adding Location Data in Photos

But what if your camera doesn't capture geotags? Good news. You can assign that information in Photos for macOS. Choose a picture, and open the Info

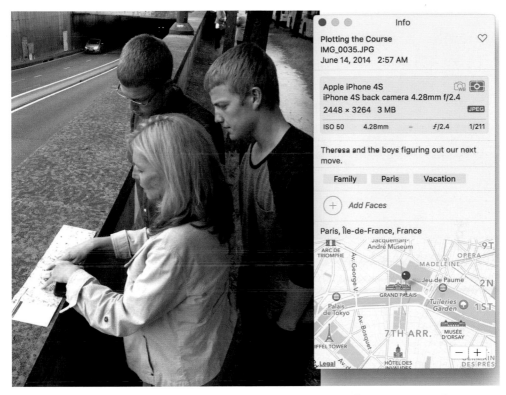

Figure 9-6: Image captured with an iPhone records when and where the picture was captured

panel. Instead of seeing a pin on a map in the bottom section of Info, you'll see the words "Assign a Location." Start typing the place where you took the picture, and Photos will offer you a list of suggestions if available. This requires an Internet connection. That's where the suggestions are coming from.

Choose the location that comes closest to the photo site. Photos will complete the name of the place and drop a pin on a map. This pin is

movable, so if you want to make an adjustment, click and drag it to its proper spot.

While you're at this, you might want to add a description, title, and a few keywords. This data will stay with the photo, even if you export it out of the application. Test it to see for yourself.

First, choose an image that has location information and some IPTC data, such as a description and title. Go to File > Export >Export 1 Photo, and

Figure 9-7: Photos will help you add the right location for your picture

make sure that the box next to Location Information is checked. Send the picture to your desktop. Now open the image with the Preview app by double-clicking on it. Open the Info box in Preview by typing Command-I, and then click on the GPS tab. Not only will you see the pin on the map, but the actual coordinates of the location. Click the Show in Maps button for a bigger view. This is a fun demo you can use next time you're showing off Photos functionality to friends.

In case you're still in Preview, return to Photos. You can also add locations to multiple images at once. Select them all, then open Info (Command-I) and assign a location. The shots I have of the Eiffel Tower are a perfect example of moving the pin for better accuracy.

I didn't take the photo from the tower itself, but from the park leading up to it. I didn't remember the name of the area, so I entered Eiffel Tower in the Assign a Location field. Then all I had to do was drag the pin closer to the spot where I took the photo.

And here's the best part: Photos filled in the name for me, Parc Du Champ De Mars. There's no way I would have remembered that, but I could point out on a map where I was standing. Now I know the name of that location too.

Figure 9-8· You can fine-tune the position by moving the pin to the exact spot

Using Search in Photos for macOS

The search function in Photos for macOS is lightning fast. And all of this location and IPTC information we've been adding is useable. Go to the search box in the upper-right corner of the photos interface, and enter a place. I tried Las Vegas.

The application will list all of the matches in its database, including location information, descriptions, and keywords. Each suggestion has a thumbnail photo to help you decide which one to choose.

You can also put this data to use via a smart album. That pulls your entire

search into one place. So all of those listings appearing below the search box are now neatly stored in a container. Use the conditions. Text - Includes - Las Vegas. Photos will include location info, descriptions, and keywords in this Smart Album.

In my quest to shine a light on underutilized features in Photos for macOS, I would add Smart Albums to that list. You can use them to search for just about anything. But the sweet part is that the results are packed up so neatly for you in the album itself. You can leave the items there and let the population grow automatically as new pictures meet those conditions. Or you can move them somewhere else, such

Figure 9-9: Search results include thumbnails to help you choose from the list

Figure 9-10: Setting up a smart album to search for Las Vegas metadata

as a slideshow or book project. (This is foreshadowing for the next chapter, by the way.)

So if Smart Albums have fallen off your radar, give them another look. They're so handy.

Metadata Badges

And finally . . .

Have you noticed that when you add a keyword or location information, a little badge shows up on the thumbnail? If not, make sure that you have the badges turned on by going to View > Metadata > List of Badges. Once they're on, the little icons will appear on your pictures.

Going from left to right: the little tag icon is for keywords, the pin icon is for location data, and the mini adjustment sliders are for pictures that you've edited. I think these are nice visual indications of what type of metadata is included with the picture.

Figure 9-11: Badges let you know what type of metadata is associated with the picture

Checking Out the Details

Another way to gather related information about a particular photo is via the Details button in the upper right hand corner of the Photos interface. This button appears when you double-click on an image to see a better view of it (that is, if you have Photos 2.0 or later).

Details isn't really taking you anywhere new, however. All of the information is already on the page below the image. Clicking on Details just pops you down there.

Once you arrive, you can view a Places map with a thumbnail of the image on it (if Photos can figure out where you took the shot), people identified in the picture, and a handful of Related Memories.

This approach is far more visual than the more traditional Info heads-up

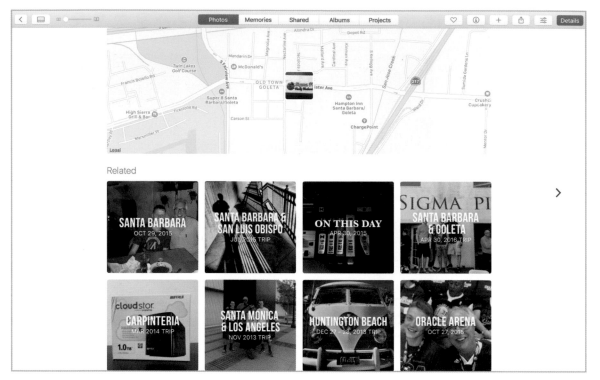

Figure 9-12: Below the image are what Photos calls the Details section

display that I discussed earlier. The most interesting aspect of Details is the Related Memories function. What typically appears for me are other collections of pictures from nearby locations. But I've also had On This Day creep in there too.

All in all, I think the Details section is interesting. Although I can't figure out why we need a separate button for it since the information is already present.

I have a feeling this area will receive a bit more fine tuning in the future.

OK, Maybe It Wasn't Magical

But you have to admit; some of this stuff is very practical. How much of it you use is, of course, up to you. Personally, I admit that I don't keyword much. (Yes, I used *keyword* as a verb.)

But I do like to add descriptions, and those words are searchable too. Plus, I'm always taking pictures with my iPhone as well as with my other digital cameras. Mainly because I like having the location information my iPhone provides.

My point is, everyone goes about data management in their own way. It's personal. And now you know the tools that are at your disposal. Use what you need, and the rest will be there waiting for you if you change your mind.

Projects and Prints

Some of my favorite Apple commercials of late have portrayed someone creating a wonderful moment with its products and then sharing it with family and friends. This is not just wishful thinking. Apple has actually made it possible for us to do the same things we see actors accomplish on TV.

With Photos for macOS, we can author professional looking slideshows, design books, print fine-art cards, and even create something beautiful to hang on the wall. That's what we're going to do now. We're going to take these digital files and breathe physical life into them.

Making It Real

The room where I work is lined with prints—big prints, on every wall. I created every one of them.

I look at these images day in and day out while I type on the computer, talk on the phone, and meet with clients. You'd think that after a year or two, I'd be tired of them. But I'm not. Sure, every now and then I'll put up a new image and store one that's a bit older. But the gallery itself remains intact.

Throughout this book I've sung the praises of digital imaging. And for good reason. It has brought the joy of photography to more people than ever. It's fun. And the tools we have, such as Photos for macOS, are wonderful.

But I think there's also a downside to digital photography. Far too often great images are trapped in computers and smartphones, never to experience the light of day. That's a shame, because stopping before making a card or printing a book leaves us one step short of completion. Why climb the mountain if you're not going to see the view from the top?

A print, a book, a card. These are things you can hold in your hands. They require no power and never become obsolete. When you hand someone a fine art card that reflects your craftsmanship at every stage— capture, image editing, and output— then how is that different than when Van Gogh gave a painting to a friend? I'm not saying we're all Van Goghs. But we are artists.

So far in this book, we've dealt with technical stuff, which is an undeniable facet of digital photography. But it's not the total picture. It doesn't make any

difference what camera you used to capture the image. Whether it began on an iPhone, a mirrorless camera, or a 35mm SLR is irrelevant. What matters is, does the finished piece reflect a little bit of you? And if it does, are you willing to commit it to paper?

Right now, you may be thinking, "Derrick, my goal wasn't to become an artist. I just wanted to learn this software on my Mac." Really? Wouldn't that be a bit like saying, "I don't want to be a painter. I just wanted to play with these brushes." Inside, don't you want to be a painter?

I suspect you're not against being an artist at all. You just didn't think it was possible. I'm telling you, you're nine-tenths of the way there.

Something happens when you put together a book of your pictures, hang a print on the wall, or mail a handmade card to a friend. You become a different photographer once you do that. Those of you who have experienced this know what I'm talking about. It changes you. You are no longer solely defined by your job, but rather by your passion too. You've created physical proof of your artistic ability.

The minute you put your pictures on paper and hand them to someone else, you've become an artist. And all of this work you've done learning how to manage and polish your images suddenly seems worthwhile.

I don't get tired of those pictures on my wall because they're a part of me.

They remind me of things I like about myself. That I have the ability to see beauty in life, capture it in my camera, nurture it on a computer, and then hang it on the wall so I can say, "I did that."

Our mission in this chapter is to create art. The same way photographers, painters, and sculptors have done for decades: by starting with a vision, no matter how small, and then bringing it to life.

The Projects Tab

If you're lucky enough to have a workroom where you can start a project, spend a few hours on it, and then leave it exactly as it is until your return, you'll appreciate the Projects tab in Photos for macOS. It's your virtual print shop.

Every time you start a slideshow, book layout, greeting card design, or other project, it is saved in the Projects tab, making it easy for you to return and pick up right where you left off. And if your endeavor is a success, you don't have to recreate it, you just print out more.

The five project types are listed when you click on the + button in the top toolbar: Book, Calendar, Card, Slideshow, Prints. We'll start with Book and work our way down the list.

Making a Book
It is said that each of us has one good book inside of us. In this case, you

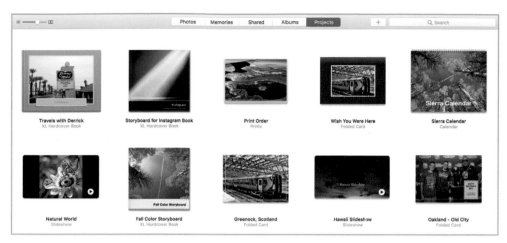

Figure 10-1: The Projects tab is your virtual workroom

probably have more than that sitting on your hard drive right now. You just have to look.

I did that and decided I wanted to make a book of my favorite Instagram shots captured over the last couple years. I've enjoyed them on my iPhone and thought it would be fun to have them in a book that others could flip through.

Figure 10-2: I place all of the candidates in an album first

My first step was to gather the images together in an album. I call this the storyboard. Here I can add, delete, sort, and get a feel for the content before sending it to the book-making tool.

After spending some time culling my pictures, I'm ready to move to the next step. I selected all of the shots in the album using Command-A. I then clicked on the + button and chose Book from the popup menu. The next screen presented me with my three choices: Square, Classic, and Softcover. Basic pricing options were presented there too, although those can vary depending on the final page count. As for format, that's an easy decision for an Instagram book: Square! I chose the 10" x 10" size.

The next choice is theme. At first there might not seem like that many to choose from, but wait. New themes with cloud badges in the corner of their thumbnails should start to appear. The badges mean that if I select one of those, it needs to be downloaded. All of this points to requiring an Internet connection to have all of the potential choices available.

I decided to pick the Picture Book theme because I know it provides lots of customizable layout options. And that's the thing about working with Books in Photos for macOS. It will initially lead you down a very easy, automated path for creating the book. But most of us are going to want more control, because once the initial layout is presented,

Figure 10-3: What kind of book?

Figure 10-4: Here's my layout in progress. I had to customize the pages to get this look.

wouldn't it be nice to go in there and adjust each page? I'll show you how that works.

When I look at the layout created by Photos using Auto-Fill, it always looks like a bit of a mess. Consider it a first pass only. The next thing I do is go through each page and adjust it to my liking. What you see in figure 10-4 is the layout that I'm working on, not the one initially created by the application.

To make those adjustments, click on a page so that it's highlighted with a blue border. Then click on the layout button in the top toolbar. It's the third button from the right. A popup menu appears with a variety of layouts based on how many pictures you want on a page. Click on the one you want, and it will be applied to the page.

At the bottom of the interface are thumbnails of the pictures still available. I've filtered them that way by choosing Unused Photos from the bottom toolbar popup. I can switch back and forth between this view and the Placed Photos view. I like Unused Photos during the layout phase. Click on any image from this area, and drag it to any page of the book. Photos will replace whatever is already there with the new picture.

While we're at the bottom toolbar, I'll mention that the Add Photos button is down there on the far right, allowing

Figure 10-5: You have many choices for the appearance of each page

you to bring in more shots to the project. And the Cleared Placed Photos button is positioned on the far left. This is only if you want to start from scratch, clearing all the placed images in the book. If you feel a wave of layout frustration washing over you, get up and walk away from the computer instead of immediately clicking this button. Call it a cooling-off period.

Before I move on to the next phase, just a couple more things to cover on the top toolbar. The Change Settings button allows you to adjust the number of pages, show page numbers, change theme, and adjust format and size. There's an Add Page button up there also. So if you run out of pages, click that. (And Apple rings up the cash register because those additional pages will cost you money.)

On the left side of the top toolbar is the zoom slider, which I think is very handy. When I want an overview of the spreads, I zoom out. And when I'm reviewing the actual layout of a page, I zoom in. The back arrow up there takes you out of the book and returns you to the main Projects tab. But your book is still there, right were you left off, waiting for you to return.

Spend some time with the layout and get it just the way you want. And before you purchase, I suggest that your preview your work. How? Make a PDF.

Go to File > Print to open the Print dialog box, and then choose Save as PDF

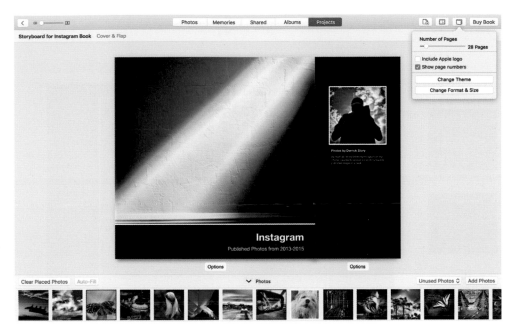

Figure 10-6: Change the overall parameters of the project here

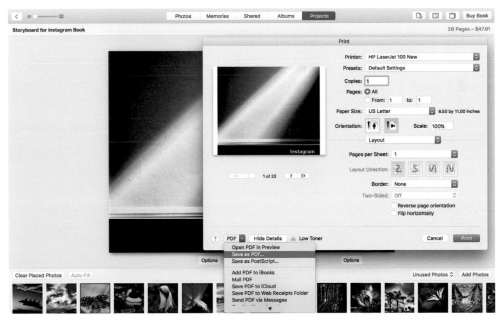

Figure 10-7: Make a PDF proof and try before you buy

Figure 10-8: Since the proof is a PDF, you can share it with others too

from the popup in the lower-left corner. Your Mac will generate a PDF file of your masterpiece that you can review on-screen, share with others for feedback, or run through your inkjet printer. This is the proofing stage. A little time here will save you money down the road.

Once everything checks out, you can make the purchase. Click on the Buy Book button, and you're led through the checkout process.

The thing to remember about books is that they're not something you rush. Believe me, I know. My hope is that you take your time and savor the process. This is the beauty of the Projects tab. Our work is always there, waiting for us to return and polish a bit more.

Speaking of which, what about my Instagram book? I think I'm about ready to send it off to the printer. If it turns out as I hope, I might even order a few to share as gifts.

Creating a Calendar

The calendar-making tool is very similar to what we just looked at for building books, only easier. The initial process is the same: choose a collection of images, click on the + button, and select Calendar from the popup menu.

Photos will then ask you what size you want, for how many months, and which month will be the first. Plus, you'll see an estimate of how much the project will cost. The next screen is the

fun one. Here's where you get to browse all of the themes available. There are quite a few good ones.

Once you make your choice, Photos for macOS flows the images into the calendar format. You'll see the thumbnails at the bottom with flowed images laid out in the calendar above. Click and drag an image from the thumbnails to a page in the layout if you want to replace one that's already there. Since most calendars are only 12 months, it shouldn't take long to get things in shape.

As you're adding pictures and moving things around, you might decide that you want to use a different theme,

add birthdays, include holidays, and the like. You can do so by clicking on the Settings button (top toolbar, second from the right).

The button to the left of Settings is Layout Options, and this is almost identical to its sibling in Books. It's particularly helpful if you don't want the standard "single picture above the calendar grid" kind of thing and would prefer a group of shots instead. You can also change the background screen color here, if that's part of your design.

Before you click on the Buy Calendar button, I recommend

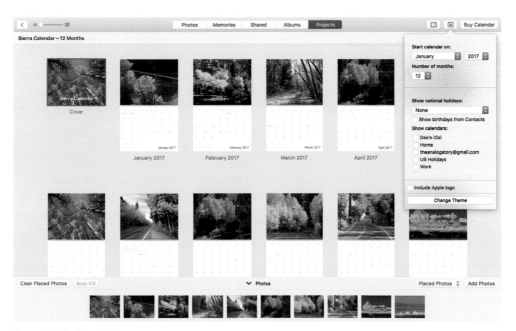

Figure 10-9: The Settings popup menu

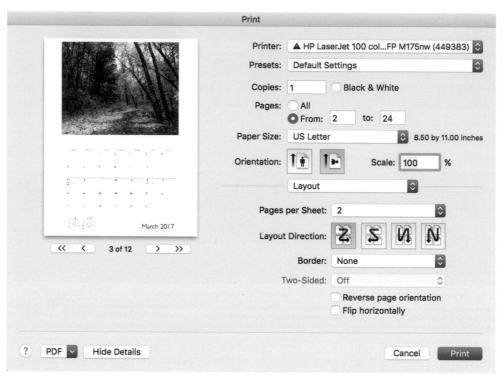

Figure 10-10: Preview your calendar

generating a PDF for review. These are easy to share or play with on your own printer.

Go to File > Print. The setup here will be a little different than with the book. Start on page 2 for the calendar. Then go to layout, and select 2 for Pages per Sheet. Now you can choose Save as PDF from the popup window. If you have any questions, check figure 10-10 for the settings that I use.

Everything look good? Then click Buy Calendar!

Designing Cards

A fine art greeting card, featuring one of your images, is one of the nicest, most cost-effective gifts you can give for those spontaneous occasions. All the design tools you need are in Photos for macOS. The application is geared for purchasing cards online. And they are terrific. But I'm going to show you how to print them at home too. And I tell you, they can be impressive.

The workflow will feel familiar if you've been exploring books and

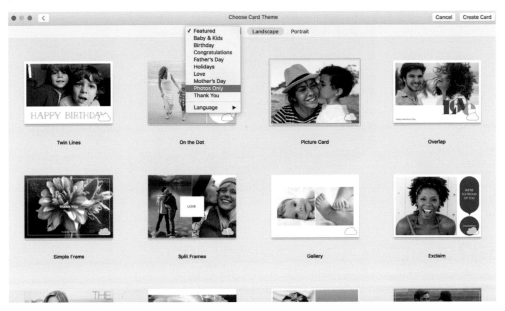

Figure 10-11: Plenty of choices for greeting card themes

calendars. Choose a photo of yours to feature, and then select Card from the + button popup menu in the top toolbar. You can pick from three options: Letterpress, Folded, or Flat. I'm going to walk you through Folded because I think it's the most versatile. Once you create the card, you'll have the option of ordering it online or printing it yourself.

Again, so many handsome templates to choose from. I'm going to pick Simple Frame for my card. I like that design element with the thin, white line.

The next step is to fine-tune the look of the card. Photos for macOS will get you started by placing the picture

in the template. But you don't want to stop there.

Take note of the three tabs at the top: Front, Inside, and Back. Start on the front. Click on the image, and then click on the Options button in the top toolbar. It's two buttons to the left of Buy Card. A floating window appears with an array of filters you can apply to the picture. In my case, I don't need those. The photography already looks the way I want. I perfected the picture back in the Editing Extensions chapter using Tonality.

Click on the button that's positioned beneath the photo. It actually reads Options, and it presents you with

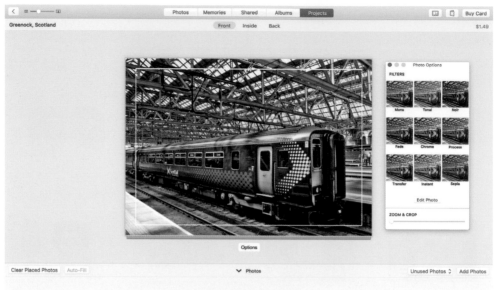

Figure 10-12: You can add some last-minute effects to your image

layout choices. Going back to the top, the Settings button (next to Buy Card) provides options for changing theme, format, and size.

Your design may have text boxes too. Mine does (Simple Frame). But I don't want text on the front, so I highlight the words and delete them. The text box

THE CONTEXTUAL POPUP WINDOW

When you right-click or Control-click on your card, there's a helpful contextual popup window with many of the commands that I discuss in this section. Some folks find these controls easier to use, especially with a two-button mouse.

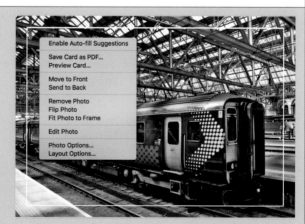

Figure 10-13: Adding text to the back of the card

remains there. So if you change your mind, just hover over it until it appears, and then click. You can then type stuff in there. I haven't figured out, however, how to move the text box to another location. If I could, I might use it more.

Continue working on the front, inside, and back of the card. Since I print mine with an inkjet printer, I leave the inside free of text and images by choosing the blank layout in Options. Then on the back, I type location, photo credit, and date. Keep in mind that this is my style for cards. I'm not saying you should necessarily copy it, but I'm showing you this as a demonstration.

Once the card is designed to your liking, you can purchase it by clicking on the Buy Card button. Photos will walk

you through the checkout process. What I do instead is print these myself using an Epson R2000 inkjet printer, which I will explain next.

CREATE TITLE SLIDES FOR YOUR MOVIES

Unless you're Woody Allen, opening your slideshow with white type on a black background can get a little dull. Instead, use the card designer to build far more interesting title slides. Start with the "Flat" card format, design the front, and then output as a PDF with the "Print from 1 to 1" setting, so the back of the card is not included. Open the PDF in Preview, export as a JPEG, and then add it to your Photos library. Your slideshows just became more interesting.

Printing Your Own Cards

Since you're going to be making stuff at home, you'll need a few supplies. I recommend that you buy a little extra, such as 50 or 100 sheets at once. That way, if you need to make a card on short notice, you have everything you need on hand. And don't forget matching envelopes!

I use Red River Paper because it offers a wide selection of card stock at very affordable prices, and you can get envelopes and ink there too (www.redrivercatalog.com).

For this project I'm using one of my favorites, 60 lb. Polar Matte double-sided 7" × 10" (catalog #1958). It's a bright paper with a nice tooth that feels good in the hands. Your cards will look and feel like works of art.

The reason why you want to go with 7" × 10" paper is because it folds down to a standard 5" × 7" card—the same dimensions that Apple uses for its folded pieces. In a pinch, you could cut down a larger sheet if necessary. But the Red River cards are also scored in the middle, which makes folding so much easier and professional looking.

As for printing instructions, I'll remind you that what appears in the dialog box is based on the print driver. So what you see on your computer might look different than what I'm showing here. Hopefully, you'll be able to take this information and adjust accordingly.

Instead of clicking on the Buy Card button, go to File > Print. You should see something like figure 10-14. If you're seeing far less information on your computer, click on the Show Details button at the bottom of the dialog. That should expand the dialog box.

Since I'm only printing the outside of the card (I like to leave the inside blank for a personal message), I choose "Print from 1 to 1." Then we get to paper size. Chances are very good that you're not going to have a 7" × 10" option in this popup menu. But what you will have there is a Manage Custom Sizes option at the bottom. Choose that, and

Figure 10-14: The print dialog box showing the setup I use for inkjet cards

make your own preset. I named mine Greeting Card.

The computer will remember the 7" × 10" preset you just created. So you only have to do this the first time.

After you have the paper size right, the card should look pretty good in the preview window. Mine came up just a tad short on the edges. So I set scale for 102 percent. That fixed the problem perfectly.

Now all that's left are the printer settings. You can find those in the popup that's labeled Layout. Click on it, and choose Printer Settings from the list. Refer to Figure 10-14 to see what I did. The most important part is having Media Type set correctly. In my case, the printer needs to know that I'm using matte paper. Check your settings one more time, then print!

Watching the card slowly emerge from the printer is the closest thing we have in digital photography to seeing an image magically appear in a tray of developer. Both are exciting.

Let the card cure for an hour or so at room temperature before folding— that is, unless it's one of those emergency jobs you're making as you head out the door to an anniversary party. Then fold and go!

As you're sitting there in the car with the card in your hand, you might feel a little something. Let it wash over you and enjoy it. That's the feeling of being an artist.

Figure 10-15: Cards that I printed at home with Photos for macOS and my Epson R2000

Making Prints

As with the greeting cards, you have two ways to go with printing. You can use Apple's printing service or generate them yourself with an inkjet printer.

Apple's Print Service

Choose your image or images to print, and then click on the + button in the top toolbar and choose Prints from the popup menu. You'll first see the basic services that Apple offers. Choose the size you want, and click the Select button. In the next screen, you'll have the chance to make some basic adjustments. If you selected a print size that has different proportions than your image, you can set the crop so it prints exactly the way that you want. Just move the image around in the yellow box.

Figure 10-16: Start by choosing the type of print you want

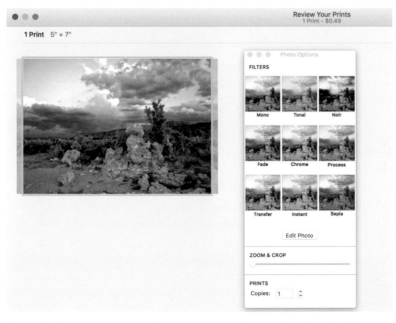

Figure 10-17: You can make a few adjustments before sending the print job

Using the top buttons on the toolbar, you also can access the settings that were available in the other projects too, such as Photo Options and change print size. And finally, you have two new options: one for white borders and the other for glossy finish. Check the appropriate boxes. Now all that's left is to click the Order Prints button and let Apple walk you through the checkout process.

Print It Yourself

For those who like the joy and adventure of printing at home, you can do that also. Select your image, and go to File > Print. You'll be greeted

with a simple dialog box that shows your image and icons of the various sizes you might select. Choose what's appropriate for the paper loaded in the printer.

You can also take advantage of the Custom option that lets you set the image size independently of the paper size, so you can float the picture if you wish. Custom should be there in the column with the other presets. When you click on it, a couple of new controls appear at the bottom of the column, letting you set the aspect ratio and the photo size. Once you have things looking the way you want, click on the Print button to go to the final step.

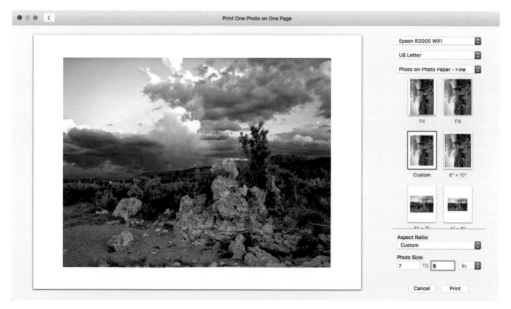

Figure 10-18: Using the custom option you can float the image on the paper

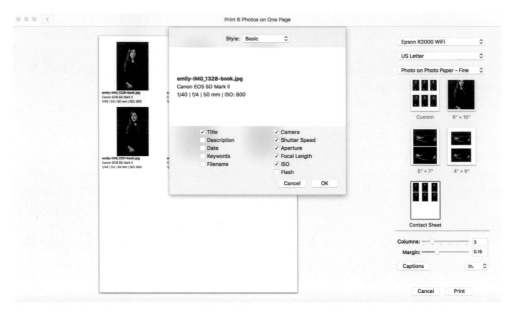

Figure 10-19: Creating a contact sheet with multiple images and adding caption content to them

The last stop is the printer's dialog box. It's the same as what we saw for greeting cards with figure 10-14. Make your selections, and then click on the Print button.

Here's a fun bonus. If you select multiple images, you'll have the option of making a contact sheet. These are great when you want to share a group of images or to save paper. Plus you can add file names and camera settings to each thumbnail too.

When you click on the Contact Sheet preset, more controls appear at the bottom of the interface to let you set the number of columns and the margin size. That's also where the Captions button is located. Click on it to choose the items that you'd like included in the caption, such as file name or ISO setting.

At this point, you may decide that you want to create a PDF of the contact sheet instead of sending it to the printer. Click on the PDF button in the lower-left corner of the print dialog, and choose Save As PDF. Now you have an electronic version that you can send to clients or friends for review.

And you didn't think that Photos for macOS had any pro features!

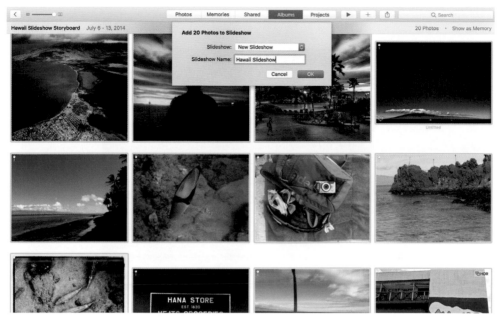

Figure 10-20: Naming your new slideshow

Authoring a Slideshow

If you've used the slideshow tools in Aperture or iPhoto, you'll probably be underwhelmed with Photos' first attempt to multimedia authoring. It works great if you just want to pick a group of images and have them synced to music. But if you like to tinker, there aren't many tools here in the workshop.

Start by selecting the images you want to present. As with other projects, I tend to create an album first, put the candidates in there, and then add and delete as needed. Then I select them all

and choose Slideshow from the + button in the top toolbar.

Photos will ask you to name a new slideshow or add the images to an existing one. You're probably going to create a new one. Then click OK. Next you'll find yourself in the authoring interface. The slides are at the bottom of the interface with the viewer above them. There are a handful of tools running down the right side.

Click on the top tool from the right-side column. It opens Themes. I recommend either Ken Burns or Classic. I'm

Figure 10-21: Pick the theme for your slideshow. We're going to work with Ken Burns.

Figure 10-22: Take control of the Ken Burns effect by setting the start and end points

Figure 10-23: Choose the music for your slideshow

going to choose Ken Burns here because it gives me the most control over the images.

You can move the individual slides around on the bottom timeline to put them in the order you want. Just drag and drop to accomplish this. Photos will automatically add motion using the Ken Burns effect. You can customize this by clicking on the faint box in the lower-left corner of the image. It reveals two sliders, one to control the

beginning of the effect and the other for the end of it.

Drag the sliders to zoom the image for the start and end of the Ken Burns effect. You can zoom in, zoom out, and drag the picture around in the frame. Click on the Preview button to check your work. Then go to the next slide and fine-tune it. You don't have to handcraft every slide individually, just the ones that you want to behave a certain way.

Figure 10-24: There are a few options you can choose from

The next tool on the right side is for choosing the music. You can use the track that's automatically associated with the theme you selected, or pick another. You can also select tracks from your iTunes library. Just remember that you can't publish commercial songs online without permission. The theme music is safe, however.

The third tool on the right side provides a couple options for managing the music. You can "Fit the Music" so the slideshow plays for the entire length of the track. Or you can click on Custom and program how long the show will last. There's also an option to fit images to the screen. It will be automatically checked for you when using the Ken Burns theme.

All that's left to do is hit the play button and enjoy. To share the presentation outside of Photos, click on the Export button. Choose the resolution, such as 1080p, and Photos will create

a file that you can post and share. As I said earlier, this isn't a complicated tool.

But your friends and family might not care. Because when you show them your presentation, they will most likely be impressed. Keep it short (two to three minutes), use only your best shots, and create a few custom title slides that I explained in the Cards section earlier. You'll bring down the house.

Make Room for Video

I was killing time one afternoon in a funky lighting shop in Santa Rosa, when a tall, slim, torch lamp caught my eye. "That would look great in my studio," I thought.

It wasn't in perfect condition, so I got it for a good price. "Even better," I thought. I couldn't wait to get it back to my studio and find a place for it.

I don't know if this has ever happened to you, but it's amazing how the introduction of one new thing can upset the balance of an entire ecosystem. In this case, the ecosystem was my studio.

At first I thought, "It can go over there in that corner." Unfortunately, there was already a table there, so I would have to find a new place for the table if I wanted to put my new acquisition in its place. "It's worth it," I thought. So I moved the table to the center of the room, figuring that I'd find a place for it later. I then put the torch lamp in the corner. "Perfect," I thought gazing at its understated, artistic lines.

Now the small matter of what to do with the table. "Well, I could put it next to that chair over there, but I'd have to move that little bookshelf."

The dominos began to fall. Four hours later, my entire studio was disheveled. But the mess was properly illuminated by a handsome, silver torch lamp in the corner. All in all, it took me two days to regain control of my working space.

I tell you this story because that's how I felt about video for a long time. Being primarily a still photographer, all of my management software is setup for handling JPEGs and RAW files. When I did record the occasional movie, I didn't really know what to do with it. There was nowhere to put it. So I'd find myself moving things around to accommodate a few video clips, only to disrupt the organization of everything. Fortunately, Photos for macOS is one of those photography apps that's video friendly. And not only can it handle my movie files, it automatically organizes them for me.

This chapter isn't for hard-core videographers. But if you like to shoot clips with your iPhone, and sometimes even with your DSLR or mirrorless camera, Photos does a great job of cataloging them. Plus you can do a little editing too.

By the way . . . I have that silver torch lamp glowing right now, illuminating my notes as I type this chapter. It's so good looking. I'm glad I was able to keep it.

Videos Recorded with the iPhone

When you make an iPhone movie, it's very similar to taking a picture in that you don't really have to think much about uploading the file or cataloging it. Photos automatically adds it to your library and to the Video album.

Speaking of the Video album, you can see all of your movies there. But over time, those can pile up, and you may want to create a few smaller collections. I recommend building Smart Albums for your various types of movies. They're easy to create, and once done, they are populated automatically.

Keywords and Smart Albums

It's funny: I don't add a ton of keywords to my still images, but I love using them for videos. I think it's because I feel like my movies are more easily misplaced among the thousands of pictures in the library. Fortunately, adding keywords is easy.

After I watch the movie in Photos, I press the CMD+K key combination to

bring up the Keyword Manager. I click on the appropriate keywords for the clip, and then I close the manager by typing CMD+K again.

Now all I have to do is build a Smart Album (File > New Smart Album) that collects the categories of movies I want to organize. I can use both keywords and geodata for the album because the iPhone automatically captures the geotags along with the clip.

That's really about all I do to keep track of my movies. Between the default Video album, and the Smart Albums I create, I can quickly find everything I capture. No disruption to the ecosystem.

KEYWORDS FOR VIDEOS

One of the keywords that you should add to every video is "movie". By doing so, you can use keyword combinations in the Search box to find exactly what you want, such as "San Francisco movie."

Viewing and Controlling Videos

When you double-click on a movie thumbnail to open it in the viewer, you're presented with a basic player control bar. There's a big play button in the middle, with backward and forward scanning buttons on each side, as shown in figure 11-3.

The scanning buttons allow you to scrub through the movie at a faster

Figure 11-1: Using the Keyword Manager with a video clip

Figure 11-2: Creating a Smart Album for my videos

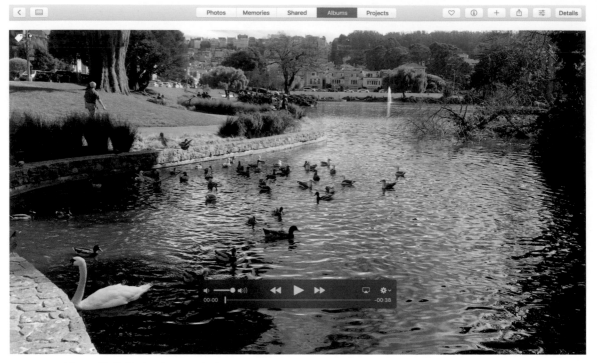

Figure 11-3: Basic player controls

speed. The default is 2X, but if you click again on the scanning button during scanning, the rate will increase to 5X, 10X, and even 30X. If you hold down the Option key while clicking on the scanning buttons, the increments are finer, starting with 1.1X, 1.2X, 1.3X and so forth, depending on how many times you click.

For even finer control, click on the gear icon in the player control bar and select, Show Frame Stepping Buttons. Now you can precede one frame at a time as your scrub through the movie. And just as with most players, you can click anywhere on the scrubbing bar to advance to that part of the movie.

Additional Gear Menu Options

In addition to switching from scanning to stepping, you can also Trim, Set Poster Frame, and Export Frame to Pictures via the gear menu.

Trimming is a fairly intuitive process. Select Trim from the gear menu, and a yellow frame appears with handles on each end. Drag the handles to the desired locations, and then click

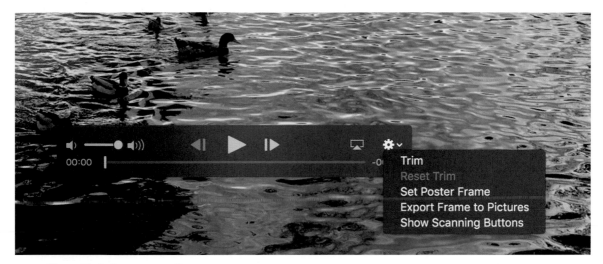

Figure 11-4: Gear menu options

the Trim button. Everything inside the yellow frame is retained, and the content on the outside is discarded.

If you change your mind later, you'll be happy to know that trimming is a non-destructive edit. Choose Trim again from the gear menu, and the entire clip is displayed, allowing you to reposition the trimming ends.

If you want to return the clip to its original state, select Reset Trim in the gear menu and all edits are removed.

While you're in this menu, you can also change the poster frame, which is movie speak for the movie's thumbnail. Instead of the first frame, which Photos selects by default, find a frame in the movie that you like better, then select Set Poster Frame from the gear menu. Ah, now that thumbnail, er, poster frame, looks better.

One of my favorite features is the ability to export a single movie frame out of the video and into my Pictures

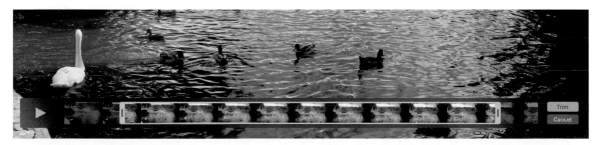

Figure 11-5: Trimming a movie

folder. This is handy for grabbing people shots or scenes from movie that I'd like to share as a standalone image.

Navigate to the frame that you want to grab, select Export Frame to Pictures from the gear menu, then jump over to your Pictures folder to retrieve the TIFF file that has just arrived.

THE BIG PRESENTATION!

You can stream your movies to an Apple TV by clicking on the streaming button directly to the left of the gear menu. Choose the Apple TV you want to use, and you suddenly have a movie theater for your production.

Stitching Clips Together

You can build an entire movie from your clips by selecting the thumbnail, um . . . poster frame, of each (hold down the Command key while doing so), and then clicking on the "+" button

at the top of the interface and selecting Slideshow from the popup menu.

Photos treats your movie clips just like regular pictures in the slideshow creator, except these are full-blown HD videos that can be combined into one beautiful production. The options I discussed in chapter 10 about building slideshows are available here too, such as adding a title, creating transitions, and including music.

The production is automatically saved in the Projects tab, so you can go back to it for additional work as desired. Once you've completed your film, you can play it right there in the slideshow work area, or you can export the movie to your hard drive by clicking on the Export button in the upper-right hand corner.

As I mentioned earlier, Photos isn't quite powerful enough for serious videographers. But for the rest of us, who like capturing wedding toasts and speeches by the father of the bride, Photos is a capable manager and a handy editor.

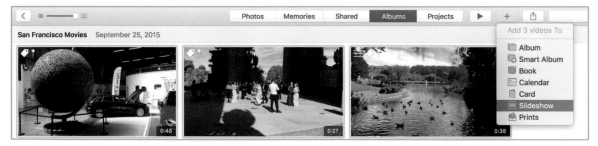

Figure 11-6: Select clips, then choose Slideshow from the "+" menu

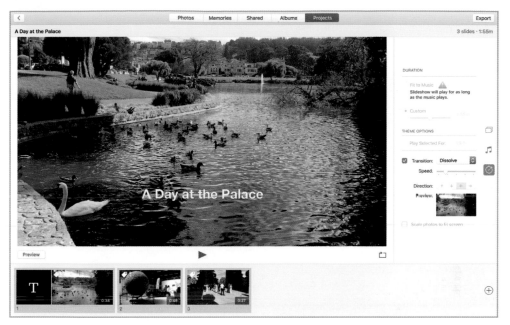

Figure 11-7: Working with video clips in the Slideshow interface

Figure 11-8: Exporting a movie

Integrating Photos into Your World

On a shelf in the recording room of my studio, I have a shoebox filled with filters. Given that I wear size 15 sneakers, you can imagine how many polarizers, skylights, and lens protectors are rattling around in there.

I bought some of these in the earliest days of my photography. They were purchased to screw into the lenses for my Contax and Canon film cameras. These days I also use them on my digital Olympus and Panasonic optics. I think it's interesting that these filters are just as useful in 2016 as they were decades ago. And when I open the box and riffle through them, it's like I'm digging through a physical diary of my photographic history.

Figure 12-1: My Contax kit from the 1980s.

And just how often are we able to use something today that we purchased more than 30 years ago?

For the Hobbyist Photographer Side of Me

In the early days of Photos, I used to think, "How can I use this?" It was so different than anything that I'd seen previously. And it prompted me to consider how I use photography tools in general. Like many pros, I'm a hobbyist too. I may use an expensive full-frame digital SLR for a commercial shoot during the day, but then come home and capture a funny picture of the cat with my iPhone.

The DSLR images are how I make my living. The iPhone pictures are what I enjoy about life. Both are important to me.

To be honest with you, I think some photographers take themselves too seriously. Every shot doesn't have to be a perfectly composed masterpiece. Life is a messy production of darks and lights, with lots of mid-tones wedged in between. The perfect device for capturing those spontaneous moments is a smartphone.

And the perfect app for managing those images is Photos. You can set up the workflow once, connect everything via iCloud, and then just let it happen.

Your images are automatically backed up and shared across all of your devices. If you edit a shot on the iPhone, the changes show up on your Mac. Use an editing extension on your laptop to jazz up a picture, and see the image magically change on your phone. I wish all areas of my life were this integrated.

But that's really just the beginning of what this app can do.

During the summer, I tutor high school kids in photography. We shoot with DSLRs and learn about depth of field, motion, color, exposure, special effects, portraiture, and more. In addition to their kit zoom lenses, they have to purchase a prime lens (usually a 50mm), a polarizer, and a tripod.

In addition to the shooting we do together, they have assignments, and they must share their work on the LCD I have connected to an Apple TV at the studio. We critique the shots, make notes, and then start working on the next project.

For all of this instruction, we use Photos. And the work these kids produce is flat out impressive.

What's interesting is that they're not worried about the features Photos *doesn't* have. They've never used anything else. They come to this application with a completely open mind, and as such, they shape the software to do what they want.

I know this sounds simple. And it is. I've never had a kid say to me, "I wish Photos did this or that." They just go

Figure 12-2: Kids learning photography.

about their business of making great images with it.

What I'm trying to say here is that if you own a mirrorless or DSLR camera that you use in addition to your iPhone, Photos can accommodate you . . . if you let it. This is especially true if you love sharing your shots online via Facebook, Instagram, Twitter, and other services.

I think where Photos breaks down a bit is for those who shoot hundreds of images a week that must be cataloged and manipulated. In other words, in my opinion, Photos is not for professional work.

But even pros need to have fun now and then. And you can't take your DSLR with its 70–200mm f/2.8 zoom lens everywhere. Go ahead, use your phone. Then edit the shots in Photos and post them on Facebook.

It's fun to be a kid.

Figure 12-3: Using iCloud Library to integrate my work

How I Use Photos for macOS

Since I have a foot in both the professional and hobbyist worlds, I thought that you might be interested in how I use Photos.

At the top of the list, is that I manage all my iPhone photography in Photos. And that's a big chunk. The way Photos 2.0 reads the metadata and organizes my images via Memories and Moments is impressive. And I haven't struggled finding my shots in the library.

In all honestly, I just let go and let Photos do its thing.

When I do need to bend Photos to my organizational will, I'll create a Smart Album for a specific collection. Once I set the conditions for this album, it automatically becomes populated. If you find yourself craving more control over your Photos library, I recommend digging deep into this feature.

Another area that has helped me integrate my images with my life is iCloud Drive. I use it to copy pictures

Figure 12-4: All of these shots came into my Photos Library via Capture One Pro and iCloud Sharing

from my professional app, Capture One Pro, to Photos for macOS.

I did this by creating a folder in iCloud Drive called Capture One Export. When I have a handful of images in Capture One that I'd like to use in my hobbyist life, I export copies of them to this folder on my Mac.

iCloud then syncs the images across all of my devices. I can then open the picture on my iPhone or my iPad, and use the Save Image command to add

it to Photos. Since all of the metadata travels with the picture, Photos then organizes it in Memories and Moments, plus adds it to any Smart Albums that are appropriate.

Almost every image that appears on my Instagram, Facebook, or Twitter accounts, flows through the Camera Roll on my iPhone, but those pictures originate in variety of places. It's the integration that allows me to share them so easily.

Figure 12-5: Use RAW as the original for image editing, if that option is available

Those Wonderful Editing Extensions

Another feature of Photos, and one that I'm enjoying immensely, is working on my images via the Editing Extensions. Yes, I know how to use Photoshop, Lightroom, and Capture One Pro. But more and more, I find that what I really want to use is Tonality, DxO Optics Pro, and Affinity.

I love how Photos integrates these apps. They are modern in their design, non-destructive, and the results are shared within my iCloud ecosystem.

How the images get to my editing extensions varies. Some come in directly from the iPhone, while others arrive via an SD card inserted into my Mac and using the Import command in Photos. What's interesting is that even if the entire card is destined to be cataloged in Capture One Pro, I might grab only a few shots, import them to Photos, and then experiment with them in one of the editing extensions.

Keep in mind that the RAW workflow stays intact in Photos as well as with its extensions. So I'm not compromising on image quality. If both a RAW and a JPEG came in through import, I select Use RAW as Original when in edit mode. That gives me the absolute best results when pushing the boundaries of creativity.

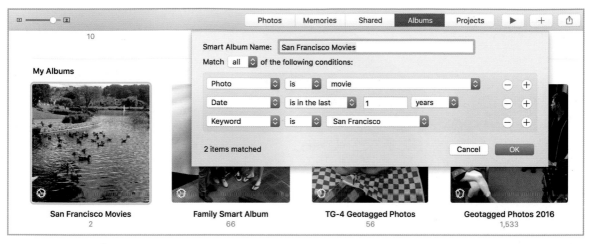

Figure 12-6: Organizing my videos in Photos

Video Management Too

And let's not forget video. Thanks to ease of capture, video has become an important part of our visual lives. And Photos does a great job of cataloging these clips.

Movies recorded with my iPhone are automatically stored in the Videos album. And since I can apply keywords to these clips, I can further organize this work via Smart Albums using a combination of those keywords and the geotags my iPhone automatically applies to the files.

I can do other things with these clips also, such as extract single JPEGs from the video, trim footage, and even stitch separate clips together into a final production with titles and music.

I could manage my movies in a separate app, but why would I? I have everything I need right here in Photos. If I decide to become a professional movie director, I'll revisit this decision.

This Is Just the Beginning

Keep in mind that we're talking about version 2 of an app that will continue to evolve. Many photographers are comparing a fledgling Photos to venerable programs such as Lightroom, which has added countless new features over the years.

And the fact that Photos is tied so closely with both macOS and iOS, means that the ecosystem will remain stable and in sync as all these properties evolve.

By now, you've probably figured out that I'm not an all or nothing guy. I like bringing things together. And Photos has become an integral part of my photography life. I hope this book will help you find a place for it in yours.

Just One More Thing . . .

There are a few pitfalls I'd like you to avoid when showing your work to others. These tend to happen because we're nervous about putting ourselves out there. The nervous part is normal, and there's not much we can do about that. But we do have some control over how we present our images.

First, never point out a flaw that bothers you in a print, book, card, or slideshow you've made. There's always an aspect of every project that we're not 100 percent happy with. Keep that part to yourself. Otherwise, the minute you point something negative out, it becomes all the viewer will see. If you don't highlight it, the chances are very good they won't notice it anyway. So mum's the word.

Along with that, when someone compliments your work, say thank you. And if they ask why you did this or that with the photo, listen to what they have to say and respond. Who knows? They may spot something that helps you improve the work.

My observation over the years has been that people are more talented than they realize. And with photography specifically, most have not reached their potential.

If you practice with the tools I've discussed in this book, you can find out how good you are. I'm not talking about bragging good. Nobody likes that. I'm talking about the satisfaction that comes from making something you're proud of.

In a world where our jobs are often less than satisfying, this is a big deal. You've invested the time reading this guide because you have an inkling that photography is an expression that suits you and that you have the potential to be good.

Follow that gut feeling, and see how far it takes you. I can tell you from personal experience: Making a beautiful picture is a wonderful feeling. And I never get tired of it.

—Derrick

Index